1981

Photography
simple and creative

Photography
simple and creative
with and without a camera

JANE ELAM

VNR **VAN NOSTRAND REINHOLD COMPANY**
New York Cincinnati Toronto

Acknowledgements

I should like to thank Brenda Herbert for her help and patience in editing this book and the pupils of Walworth School and Youth Centre who have tried out the ideas and provided some of the examples, and also Colin Lowson, Warden of the ILEA Art Teachers' Centre, with whom I worked on a few of the photographs.

This book was designed and produced by
The Herbert Press Ltd, London, England
Printed in Great Britain by
Jolly & Barber Ltd, Rugby

Published in 1975 by Van Nostrand Reinhold Company
A Division of Litton Educational Publishing, Inc.
450 West 33rd Street, New York, NY 10001, U.S.A.

Van Nostrand Reinhold Limited
1410 Birchmont Road, Scarborough, Ontario M1P 2E7, Canada

16 15 14 13 12 11 10 9 8 7 6 5 4 3 2 1

Library of Congress Cataloging in Publication Data
Elam, Jane.
 Photography, simple and creative.

 Bibliography: p.
 1. Photography, Artistic. 2. Photography – Special effects. 3. Photographs. I. Title.
TR642.E4 1975 770'.28 75-12164
ISBN 0-442-22280-7
ISBN 0-442-22281-5 pbk.

Contents

Introduction

The main aim of this book is to get away from the idea that photography is simply a means of recording reality, a limited technical device for producing a straightforward image of people, places or events – and to show how it can be used as an exciting experimental and creative medium. Many books have been written about straight photographic techniques, but too few about exploring the use of photographic images in an inventive way. Every trick or accident in the making of a photograph has aesthetic potential and encourages the development of visual awareness, and photography should be considered as a serious form of artistic expression.

Right at the beginning of its discovery in the nineteenth century, photography was thought of as an artistic medium and the early photographers regarded themselves as artists. Certainly they were often highly inventive and creative, though often their creativity was thought by other people to be a trick or some sort of magic. However, then, as now, any process or experimentation was worth trying out and pursuing.

Many of the techniques used today were explored in the very early days of photography – for example, diffusion of focus and distortion of the image – and many of these ideas coincided with the Impressionist Movement in painting. Photographers, like painters, believed that it was legitimate to change. or distort the look of things in order to create a certain mood or impression.

Images were multiple-exposed and superimposed in photography in the 1880's, whereas this technique was not really used in painting until the Cubists and Futurists some thirty years later. Marcel Duchamp was profoundly influenced by photography in 1912, as can be seen in his painting *Nude descending staircase*.

In 1920, photograms – photographic prints made

without a camera – really came into their own, although they are, in fact, older than photography; in the early days they were known as photogenic drawings. Soon after Cubism, photography without a camera took on a new importance and was used by artists such as Man Ray and Moholy Nagy in the twenties. For Moholy, photography helped to bridge the gap between fine art and industry, and through his teaching at the Bauhaus his influence was tremendous.

The next great exploration of photography was photomontage – the combining of different images and the inventive use of positive and negative images, by people such as Boucher and Feininger.

Recently, the link between photography and painting has become much closer through the use of the silk screen process and the work of such artists as Warhol and Rauschenberg.

Today, most art colleges include photography in their courses and it is also playing an increasing part in the art departments of schools, not only as a method of recording but also as a medium for creative expression and a stimulus to other art forms. In junior schools, where equipment and scope may be more limited, the magic of making photograms can be used as an introduction to new visual experience and to later work with a camera.

For anyone who is interested in creative visual communication, even the simplest photographic techniques can provide a fascinating and revealing medium. Many exciting results can be achieved without any previous knowledge or experience, and some of the experiments I have suggested in the book can be carried out with the minimum of equipment. I have intentionally limited the field to black and white photography and to photography by natural light (with the exception of the use of moving lights for specific experiments). Photographs can be taken in surprisingly poor light conditions, both indoors and out, if a fast film is used and if the lens on the camera has an adjustable aperture which can be opened wide to f/1·8 or f/2. Technical instruction in the use of flash and artificial lighting can be found in many books, and in

order to concentrate more on the spontaneous experimental approach it has not been included here.

This book is, therefore, an attempt to show the very wide range covered by black and white photography, and to provide a simple guide to the basic techniques involved. I hope that it will be a source of ideas and encouragement, as well as practical advice, for all those (whether they be teachers, students or amateur enthusiasts) who would like to explore the scope and the fascination of photography beyond its narrow use as a recording device.

Note
To emphasise the importance of creative enterprise, I have left the explanation of equipment and the techniques of developing and printing until the end of the book. Some people may prefer to read this final chapter first, or to refer to it while reading the earlier chapters.

1 Experimenting without a camera

Photograms

Perhaps the best way to start with creative photography is to experiment with techniques which do not require a camera. The method is basically very simple and yet the variety of results can be almost limitless and will certainly help you to understand the fundamentals of photography. It is significant that the first photograms – photographic prints made without a camera or negative – were being produced half a century before the technique of photography itself was invented.

Any object placed on sensitised photographic paper underneath a light source, to block out wholly or partially the light falling onto the paper, will make an image when the paper is processed. Solid objects will produce a clear black and white print, whereas thinner, more transparent objects will produce a range of tones from black through greys to white. The light source from a photographic enlarger is the most satisfactory for making photograms, although any really bright light that can be directed onto the paper would do for your first experiments. As with ordinary photographic printing, photographs must be made in a darkroom, using an orange filter in the safelight. The exposed paper should be processed (i.e. developed and fixed) in the same way as for prints made from negatives, described in detail in chapter 5. Instructions for setting up a simple darkroom and using an enlarger will also be found in that chapter (pages 86 and 84).

Before making your first photogram, it is important to test the photographic paper to find out how much light is needed to achieve a strong black image. To do this you can make a test strip. Cut a strip of paper six inches long and cover all but one inch of it with a sheet of thick card which will block out the light. Expose it for five seconds under the light, then move the card so that two inches of the

paper is uncovered and expose it again for a further five seconds. Continue in this way, uncovering an inch at a time, until the whole strip of sensitised paper except for the final inch has been exposed to the light. The paper must then be developed and fixed, and the exposure time given to each strip can be marked on it as a guide for future photograms (fig. 1).

The contents of a pocket or handbag can be used for trying out your first photogram. It is easier to start with solid objects, as these will not require such critically accurate exposure time as semi-transparent ones. So experiments can be made with a variety of small objects – nuts, bolts, pins, paper clips, keys, combs etc.

1 Test strip for photograms. The white stripe was covered throughout exposure, the pale grey stripe was exposed for five seconds, the middle grey for ten seconds, and so on to the solid black stripe which was exposed to the light for twenty-five seconds

2 A first exercise in making photograms: the contents of a pocket, arranged at random, already showing some of the possibilities of different tones in the semi-transparent grey of pill bottle and comb

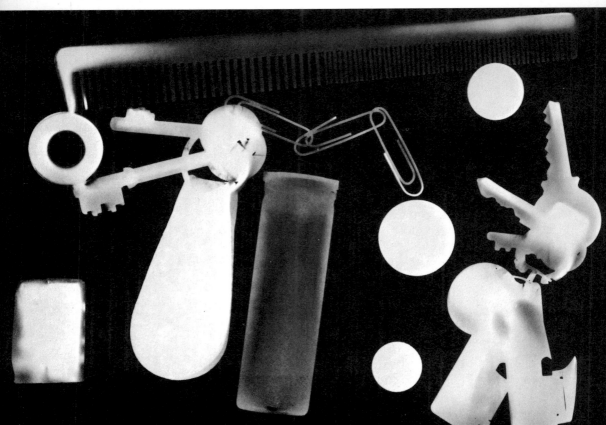

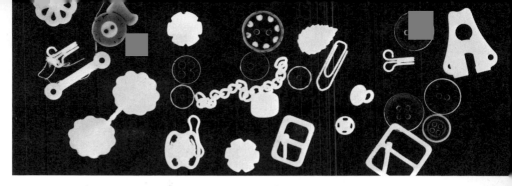

3 Collection of small objects from a button box. More of the possibilities of size, shape and translucency are being discovered, as well as the effectiveness of a somewhat haphazard arrangement

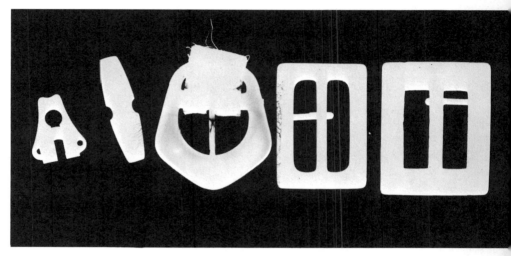

4 Fasteners, buckles and toggles forming strong white shapes and also showing the importance of the black shapes in between

5 A photogram of safety pins and small nails, producing a combination of rounded and spiky lines

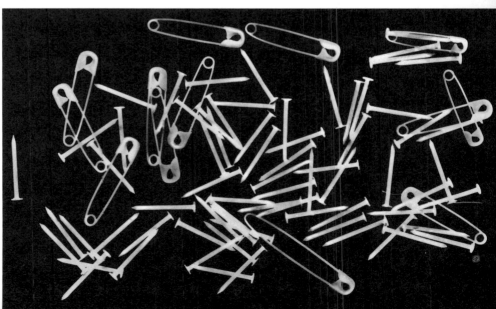

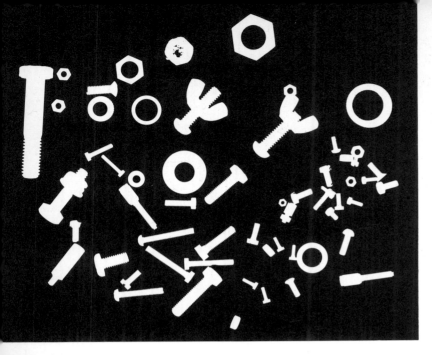

6 Another random collection of nuts, bolts and washers, forming a striking pattern of strong white forms

7 A whisk, cooking tongs and a plastic grater – all everyday kitchen objects – strikingly transformed in this photogram. One is suddenly made aware of the shapes and patterns in a new way, and of the aesthetic strength of functional design

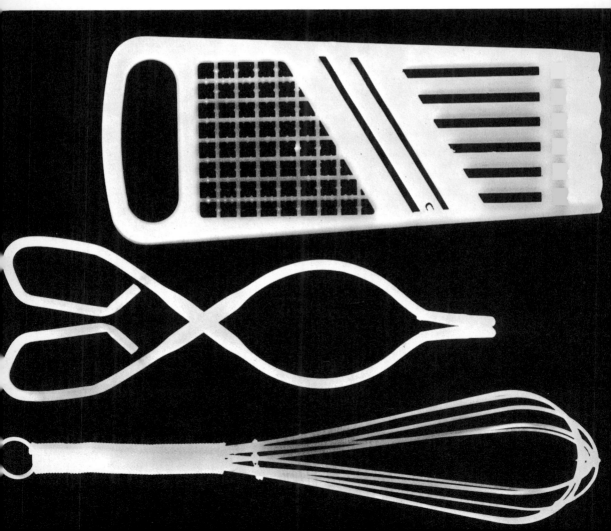

Many larger objects, either singly or in groups, can be used to make strikingly effective photograms. Mechanical objects which have a pleasing outline or which have shapes punched out are suitable; for example, cooking utensils, carpentry tools, cog wheels.

As you experiment, you will begin to be aware of the pattern values of different shapes and the spaces between the shapes, and to notice the variety of tone produced by semi-transparent objects.

8 Another arrangement of strictly practical objects, this time from the woodwork shop, which form a strong, forceful pattern of black and white shapes

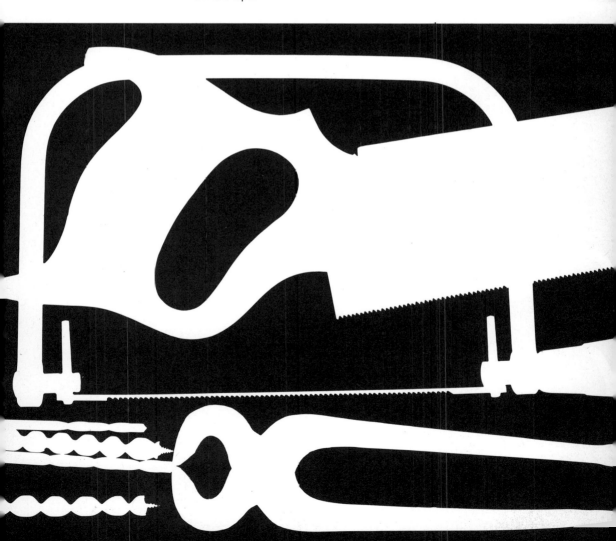

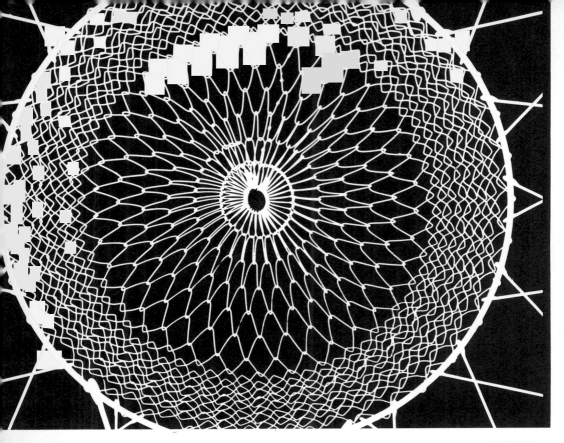

a

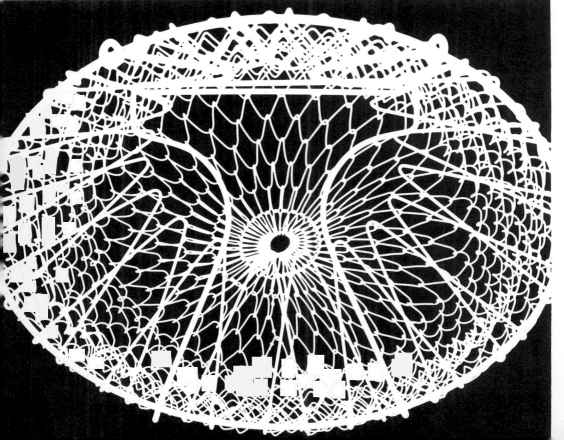

b

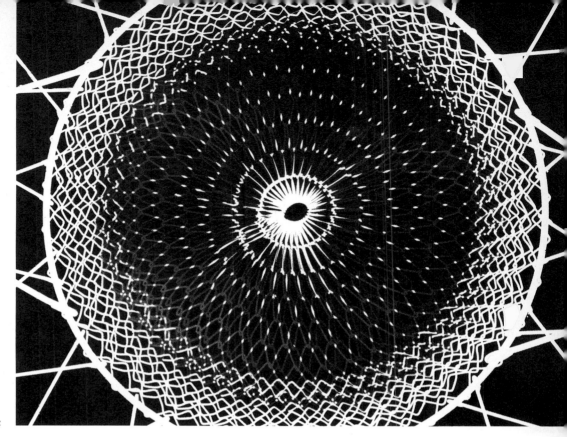

c

9 Three photograms of a wire lettuce-shaker showing how one object can be developed as a theme with varied results:
a a straightforward photogram of the lettuce-shaker opened out, showing a beautifully intricate, radiating pattern rather like lace
b the shaker closed, producing an oval form with a more complicated arrangement of overlapping white patterns
c here the object was moved in the centre, halfway through exposure, producing a grey pattern with small diamonds of white where the light was blocked out during the entire exposure time

Another way to experiment is by making a series of photographs of the same object in different positions, as shown in fig. 9. Additional variations can be achieved by moving the object half way through the exposure time; the light must be switched off while the object is rearranged or moved slightly, and exposure is then continued for the remaining amount of time.

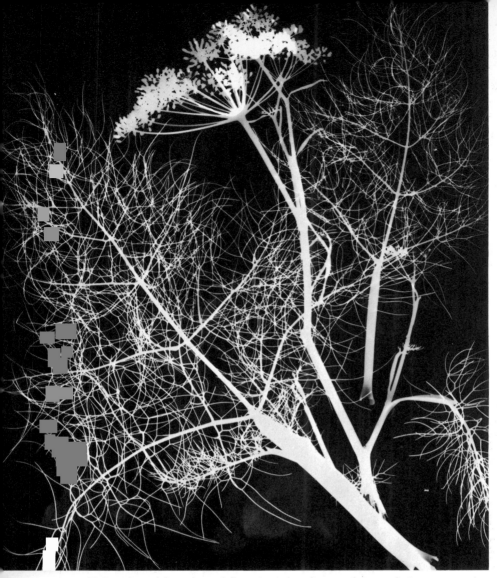

10 A spring of fennel carefully arranged to form a pleasant design within the rectangle of the paper; the strong white lines of the stem, the formal arrangement of the umbel flower head and the wild delicate mesh of the foliage all enhance one another

When you have made some photograms of an assortment of solid objects, try using others that are more delicate. All kinds of plant forms are ideal for this. The light penetrating the leaves will often show up the pattern of veins so that a variety of tones and an effect of translucency are obtained. Here you can see three examples of how fascinating this kind of photogram can be. With delicate forms it is preferable to put a sheet of clean, unscratched glass on top of the object on the paper to ensure that it is flat and does not move.

11 A plant severely attacked by snails is transformed when light is passed through it, exaggerating the holes so that they form a beautiful pattern and contrast with the fine hair-lines of the remaining veins

12 A photogram of grasses; notice the contrast between the strong vertical stems and the delicacy and varied shapes of the heads, and how some grey tones can be seen where the light has begun to permeate through

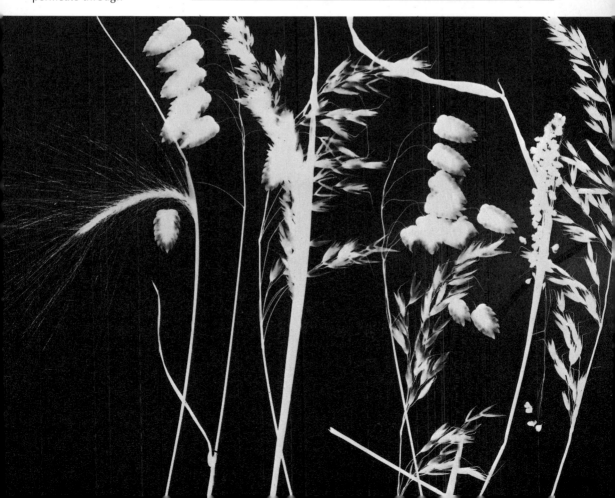

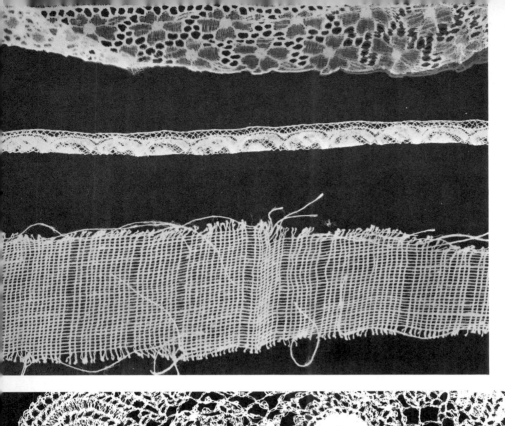

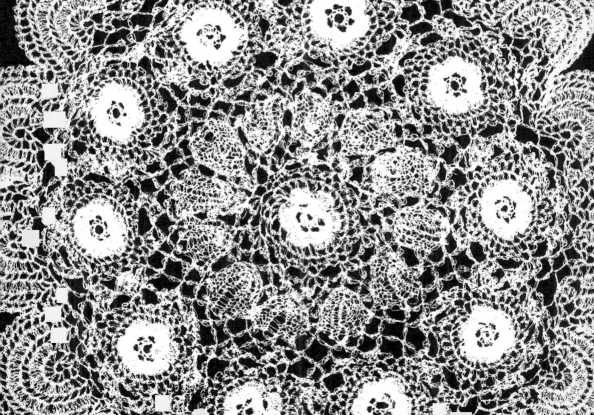

13 Photogram of net bandage and lace in contrasting strips

15 The intricacies of the piece of lacy knitting are seen more clearly in a photogram because the light passes through the tiny holes which the eye would not normally notice

14 Photogram of a crochet mat, which looks very like a photograph taken against a black background. This can be compared with other circular forms, e.g. the lettuce-shaker on page 14

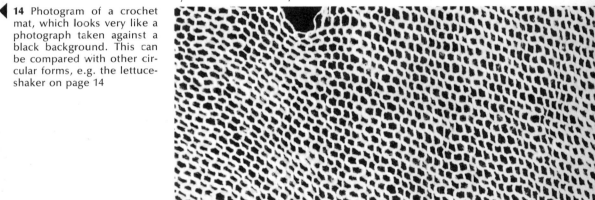

16 Even such a mundane object as plain knitting with a hole in it takes on new significance when presented as a photogram

A number of different effects can be created in photograms with the textures and patterns found in fabrics and threads; for example, cotton and woollen yarn, string, hair, net, hessian (burlap), woven and knitted fabrics, lace, crochet and knitting. As with plant forms, interesting details of pattern and structure which are not usually noticeable will often be revealed when the light passes through them onto the paper. In this context you could also try using wood and metal shavings, or the crinkly paper straw used in packaging.

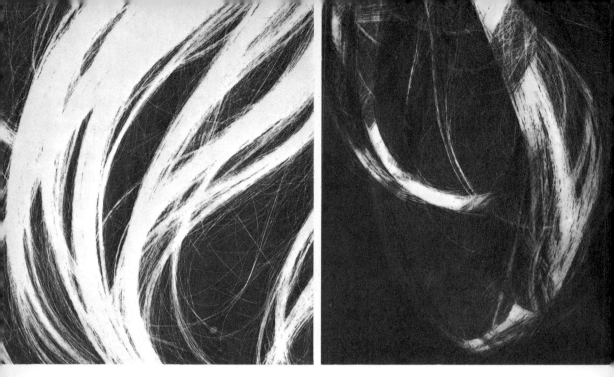

17 Two photograms of hair; in the right-hand one the hair was moved half-way through exposure (see page 15) to give a more tonal effect

18 Photogram of paper packaging material

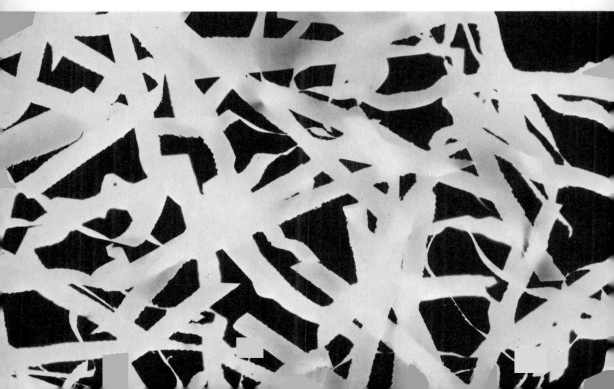

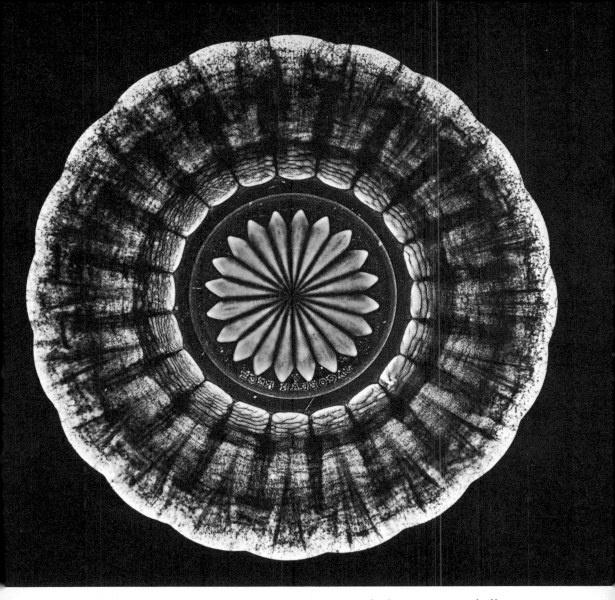

19 and **20** Photograms of cut glass objects, showing the texture of the worn surfaces

Perhaps the most magical photograms of all are those of glass objects, particularly when they have something inside them (such as the filament in a light bulb) or have different reflective surfaces like cut glass. A cheap cut glass dish or ashtray becomes a thing of great beauty in a photogram, because of the exquisite texture of the worn surfaces which is revealed when the light is projected through them (figs 19 and 20); and the glass stoppers in fig. 21 produce a series of bold shapes with fascinating textures inside them which look rather like ink-blot patterns. It is very hard to foresee the results of photograms of this kind.

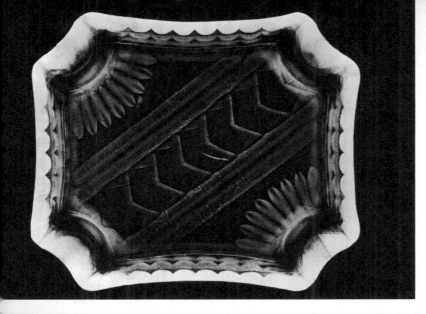

21 A collection of glass decanter stoppers

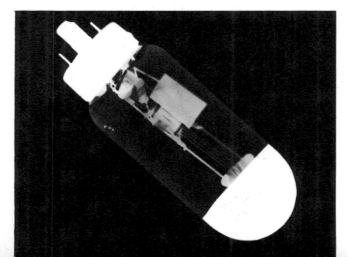

22 Photogram of an electric bulb which makes it look more like a space capsule

23 A photogram of a series of valves, varying slightly in size, pattern and shape, shows a fascinating repetition of similar objects ▶

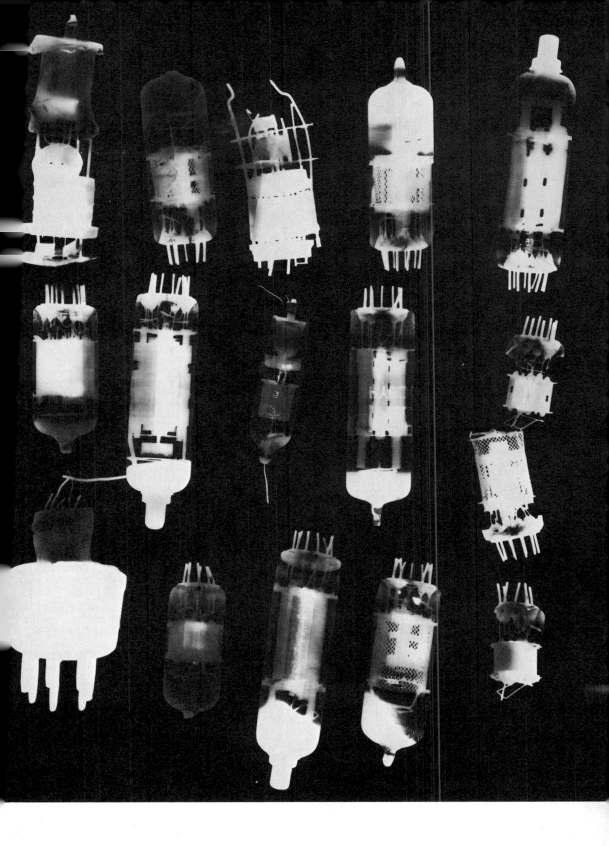

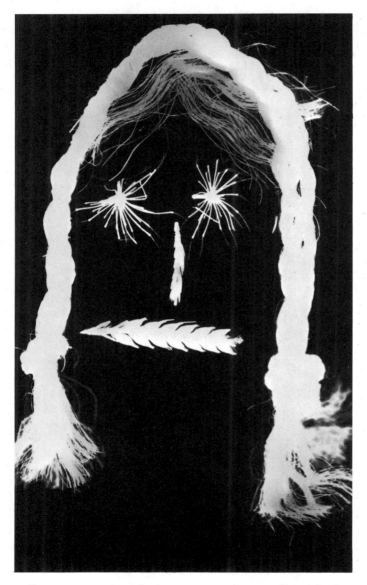

Representational pictures can be made with the photogram technique. The possibilities are endless and provide plenty of scope for the imaginative use of different materials. Figs 24–6 show some simple heads made by laying down on the photographic paper an assortment of string, seed heads and straw, nuts, bolts, screws, washers, metal shavings and split peas. Other methods of making photograms with representational images are described later in this chapter, on pages 36–7.

25

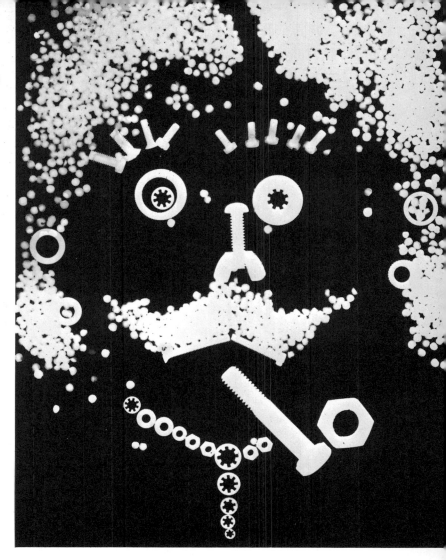

26

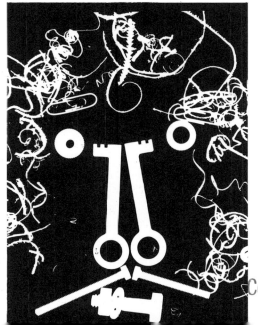

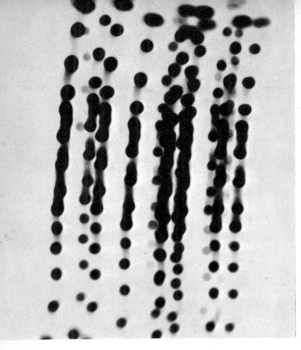

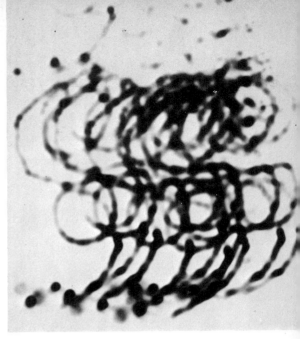

27

27–31 Five experiments using a sheet of cardboard pierced with a needle to make photogram drawings with light

28

29

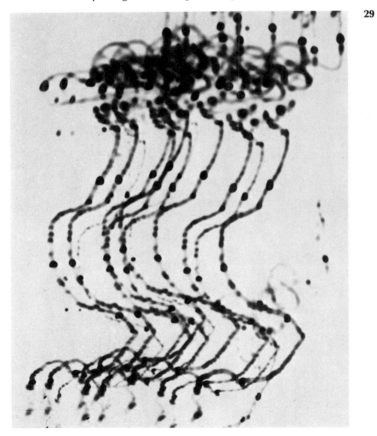

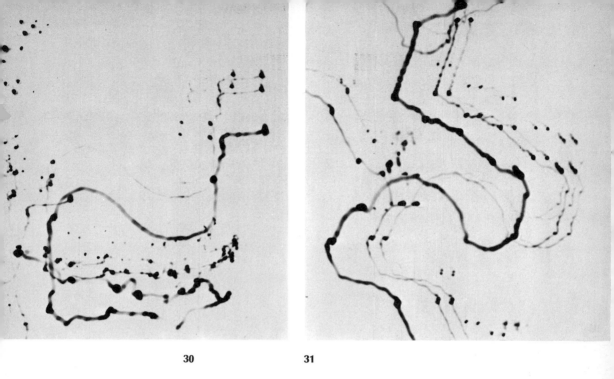

30 31

Photogram 'drawings' can be made with a light source, either by using a small hand torch and moving it round over the paper, or with a sheet of card in which a hole or series of holes has been pierced with a needle. The photographic paper is placed on the base of the enlarger and the sheet of card is held above it under the enlarger light and moved in various ways. Regular movements will produce lines on the paper, and if the card is held still, blobs will appear. Some examples of this are shown in figs 27–31.

Up to this point the enlarger has not been needed except as a source of light for making contact photograms – that is, with the photographic image the same size as the object. Some objects, however, are too small and delicate to be effective as contact photograms, and these can be placed between sheets of clean, unscratched glass in the

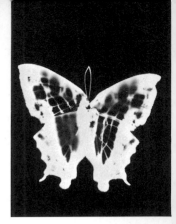

32 Photogram of a butterfly, (a) actual size and (b) enlarged in the negative carrier of the enlarger. Note the tremendous increase in pattern, texture and tone obtained in the enlargement

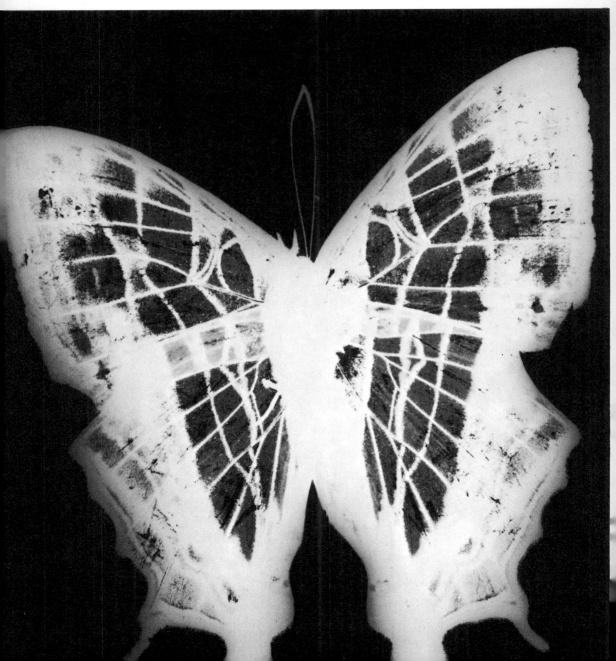

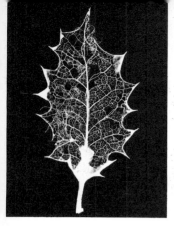

negative carrier of the enlarger (see fig. 93 on page 85). A whole new range of possibilities can be explored in this way; it is amazing how patterns and textures alter when they are enlarged, especially when the whole outline of the object can no longer be seen. The process of enlargement will often

33 A holly leaf which has become dried and skeletal is very delicate and beautiful as an actual-size photogram, and becomes something quite different when part of the leaf is enlarged, with the network of veins in striking contrast to the strong, triangular points of the prickles

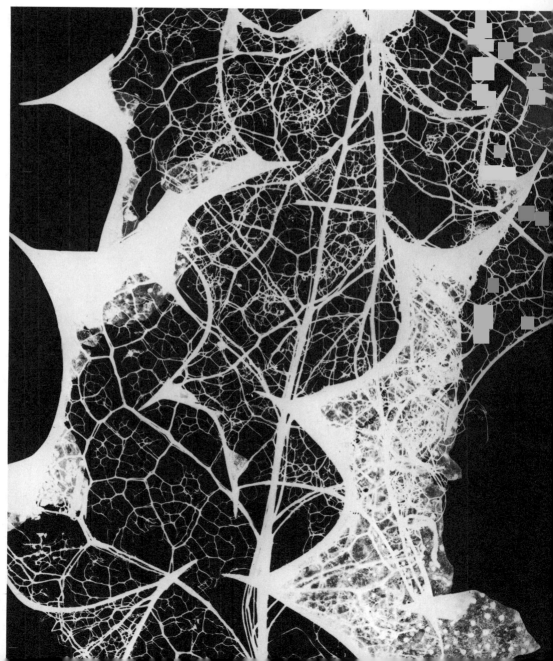

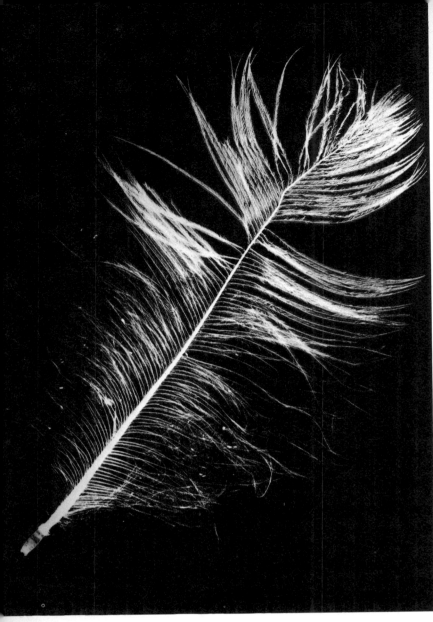

34

reveal the structure of natural forms and its specific functional purpose, as in the photogram of the feather (fig. 35) where you can see the minute hooked threads that link the barbs to provide strength and resistance to the air.

This method could be tried with small flowers and leaves, seed pods, feathers, insects; it is also possible to make very exciting enlarged photograms from microscopic slides in the same way.

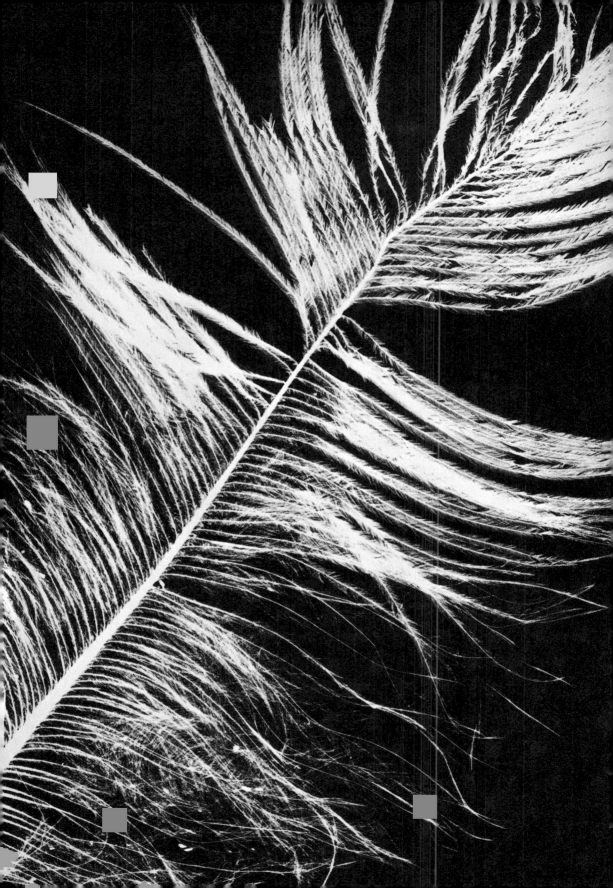

36 Two photograms of transparent adhesive tape scrumpled up and stuck to itself and enlarged in the negative carrier so that the patterns made by the folds and twists of paper can be seen more clearly

Interesting effects can be achieved by using paper to form a mask for photograms. Different types of paper will produce very different results because of the variation in their density and the amount of light that can pass through; for example, transparent self-adhesive tape stuck to itself will form many patterns and textures (fig. 36); and thin paper such as tissue can be used either flat, in overlapping layers, or crumpled, to give a semi-transparent result.

37 Photogram of a single punched card

38

39

40

38–40 Patterns made by laying one punched card over another

Sheets of cardboard or thick paper with punched-out holes or cut-out shapes can be used alone or combined in different ways to produce patterns. You could use machine-punched card made for packaging, as in the examples in figs 37–40, or make your own with a hole-puncher or by cutting out shapes with scissors or a sharp knife.

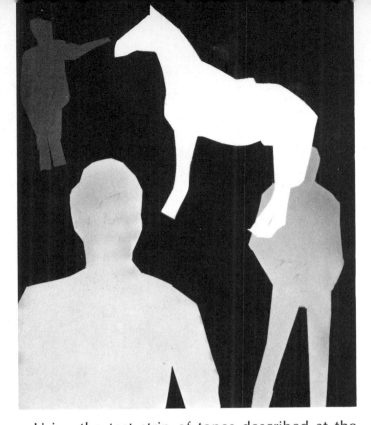

41

41 and **42** Tonal pictures made by masking the printing paper with cut-out shapes at progressive stages during exposure

Using the test strip of tones described at the beginning of this chapter as a guide, it is possible to design a tonal picture or pattern by arranging cut-out paper shapes to mask the printing paper for the appropriate amount of time required to produce each different shade. Figs 41 and 42 show examples of this. In the illustration opposite the shapes were carefully cut out from a rectangular piece of paper, taking care to cut round the shapes without cutting into them or across the background. Both the shapes and the background from which they were cut were kept. The background was used to mask the printing paper from the beginning of the exposure in order to produce the white background of the photogram. The cut-out shapes were replaced in their background at intervals during exposure, to produce the various tones of grey. The lines occurring around the shapes where they were not quite accurately replaced, add to the effect of the finished print.

In the illustration above, shapes were cut out of paper and placed on the printing paper at intervals, as before, allowing each shape a different exposure time. In this instance, however, the horse was

placed in position before exposure began, the man in the foreground next, then the man in the middle distance, and finally the figure in the background. By leaving the surrounding area unmasked for the full exposure time you achieve a black background with shapes of white to mid-grey against it.

When making tonal pictures in this way, it is of course necessary to switch off the light source while each new piece or shape is added.

38

Negatives without a camera

In addition to making photograms, you can also experiment with making negatives without using a camera. To do this you will need either to obtain old-stock sheet film which has not been used (most photographic dealers can supply this), or use clear film and paint it all over with Indian ink. A design or image can then be scratched onto the film with a compass point or other sharp-pointed instrument which will remove the emulsion on the film, or the black ink, where the lines are made. This can then be printed in the enlarger in the same way as an ordinary negative, as described in the section on printing photographs in chapter 5. Very fine, delicate black line prints can be obtained in this way (fig. 43).

In this chapter I have described a variety of ideas and methods for experimenting with photographic printmaking without using a camera. My examples are intended only as a guide; the possibilities are endless, and each individual should explore and develop his own ideas. It is a great mistake to think that photography must necessarily be confined to work with a camera. The fundamental elements of photography – i.e. light and its effect on light-sensitive surfaces – can be more clearly understood in experiments that do not involve the use of a camera negative; and you will discover that the most unlikely things produce exciting images and that unexpected results are often the most fascinating.

43 Print from a negative made without a camera

2 Experimenting with a camera

In this chapter I shall suggest ways in which you
can take unusual and exciting photographs with a
camera. Advice about the merits of different types
of camera and film will be found in the equipment
section of chapter 5, but you can start to explore
the creative possibilities of photography with even
the simplest and cheapest camera, providing that
the weather is bright and sunny.

Subject matter and composition
It is obviously impossible to make any rules about
the choice of subject for photographs, as in any art
form the subject and the way it is interpreted are a
matter of personal expression and must depend
on the decision of the individual. However, some
guide lines and things to look for can be sug-
gested. The range of subject matter is vast; there-
fore selection and a keen eye for the visually
interesting are essential. Certainly work with a
camera is an enormous help in the development of
visual awareness.

 It is not always necessary to go far afield to find
interesting things to photograph. Your own street
or garden, the local park, the school playground,
can all provide possible subjects. It may be a good
idea to plan beforehand the kind of subject you
will look for, in order not to be confused by too
much choice – but it is also important to be con-
stantly on the look-out for the unexpected. If you
are taking a group of students out for a photo-
graphic expedition you could perhaps suggest that
each member of the group select a different theme
to explore. (Some ideas for themes are given later
in the chapter).

 In black and white photography the qualities
of strong shape, pattern and texture are all-
important. It is pointless to be carried away by the
brilliant colours of a certain subject unless there
are variations of light and dark, for the colours may

not even show up as a contrast of tones in the black and white print.

For most photographs it is important to consider contrasting and comparative textures and patterns – for example, rough and smooth, plain and decorated. A series of photographs exploring the different textures alone in a given area can produce fascinating results. For instance, a neighbourhood which may seem aesthetically and visually barren when first looked at will often turn out to be full of extraordinary textural surfaces. Figs 44–8 are a series of photos taken in a decaying urban environment on the theme of texture and decay. This small selection demonstrates how stimulating such scruffy, dilapidated and, to many people, ugly surroundings can be, if the eye is trained to look for interesting visual surfaces and patterns.

The first illustration (fig. 44) shows the contrast between different surfaces on a boarded-up house and shop front: the brick, the corrugated iron, the peeling paint, the paving stones, the wire netting,

44-8 A series of photographs on the theme of textured surfaces in a decaying environment

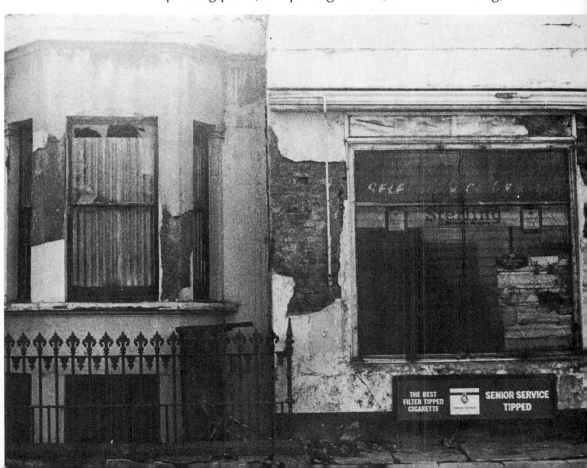

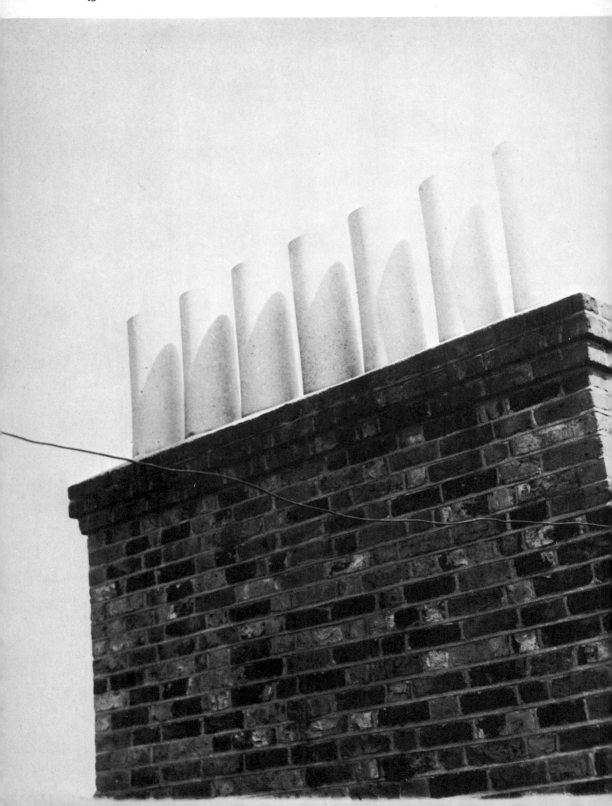

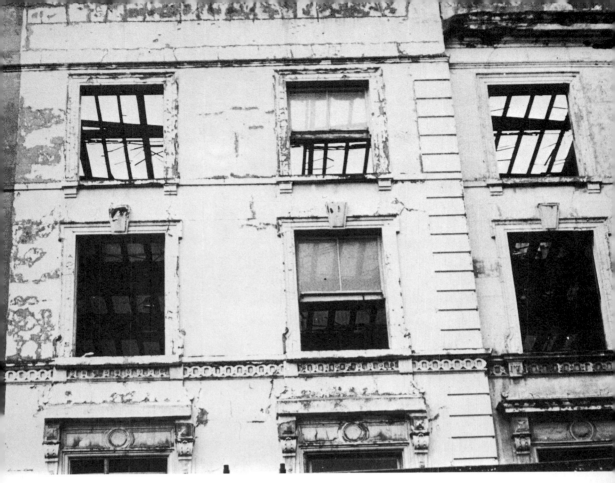

and the strong pattern of the wrought iron railings are all important. The grainy quality of the print adds to the interest of the subject matter, and was achieved by taking the picture with a fast film and a single lens 35mm reflex camera and then enlarging it considerably. (Graininess is described in more detail on page 83, and other examples can be found in figs 51, 57 and 62.)

Fig. 45 shows a chimney stack, a ridiculously simple choice of subject which makes a striking photograph. Its success depends on the contrast of texture between the very strong brick and the finely speckled, smooth chimneys and the shadow thrown by one on to the other.

Fig. 46 shows the demolition of once-splendid houses which have fallen into decay. The texture of peeling paintwork is important, but more crucial is the pattern of the windows and surface decoration and the rib-like skeletal structure of the roof framed by the windows.

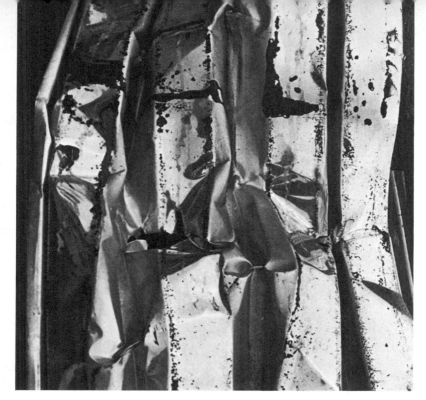

47

48

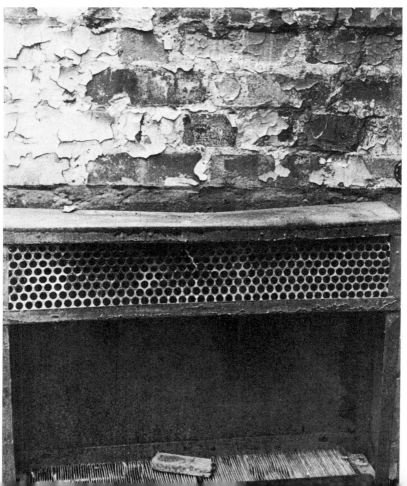

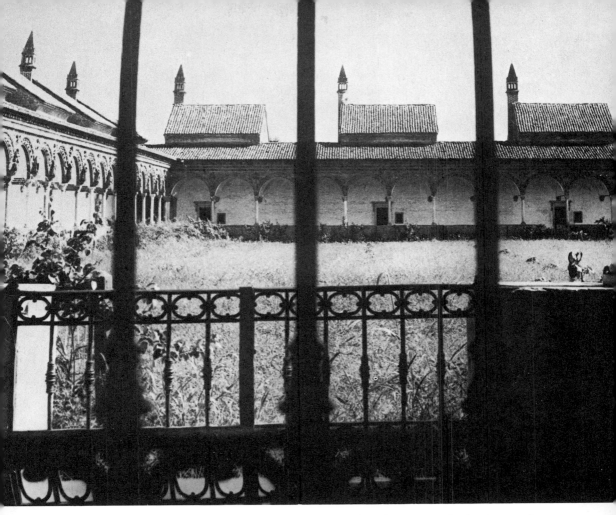

49 Photograph of an Italian monastery, showing the effect of repeating images. It was carefully composed so that a roof and a tower appear between each vertical bar of the railings in the foreground

Fig. 47 is a photograph of a crumpled piece of corrugated iron – a study in lines and surface textures, showing how effective a close-up picture can be. Fig. 48 is another close-up study of peeling painted brickwork contrasted with punched-out metal and other surfaces.

Vertical and horizontal lines can be used to great advantage in photographs. Subjects such as scaffolding, modern buildings, railways, a flight of steps or an avenue of trees, provide enormous scope for inventive and exciting composition, especially as this type of subject will often include interesting variations of light and shade or thrown shadows (as in the photograph of the chimneys in fig. 45). Repetition of the same, similar or contrasting images can also be used to good effect in composing your photograph; an example of this can be seen in fig. 49.

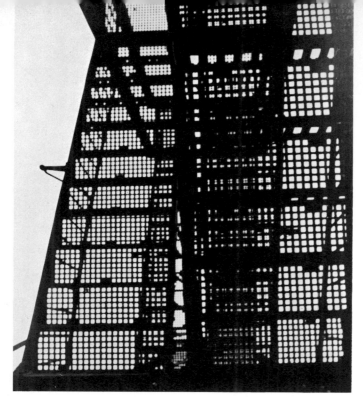

50 In this photograph of an iron fire escape the strong black and white pattern shows up particularly well because the subject was taken from underneath against the light. Notice the repeating horizontal lines and the way the light comes through the grid of the steps

The importance of the interchange of dark and light areas on a photograph is very interesting. The eye should already have been trained to look for this through work with photograms. The setting of a light subject against a dark area and a dark subject against a light area within the same negative is often possible and can greatly enhance the qualities of the finished print. Many subjects are effective shot against a bright sky so that they appear simply as a strong silhouette.

It is useful to get into the habit of composing the picture in the viewfinder of the camera, particularly when using a 35mm camera as the proportions of that format are good for the finished print. At the same time, it is important to remember that it is possible to select only part of the negative for enlargement, particularly with the larger negative of the 120 film.

With a reasonably good camera that has a variety of lens apertures, use can be made of the depth of field and change of focus. It is possible to take the same subject with the foreground in focus and the background out of focus, or with the foreground out of focus and the background crisp, or with everything in focus from three feet to infinity.

These effects can be used to pictorial advantage and should be considered carefully when composing a photograph in the viewfinder and setting the appropriate aperture on the camera.

Never be afraid to get close in to the subject you are photographing – as close as the focusing on the camera will allow (or occasionally even closer for certain effects such as an intentionally blurred or out-of-focus object in the foreground of the picture). Many subjects are improved enormously by this treatment, particularly people. The quality of the photograph of an old man in fig. 51 is heightened by the detailed visual comparison between the textures and patterns of his striped jacket, his lined and wrinkled face, and his 'pepper and salt' tweed cap.

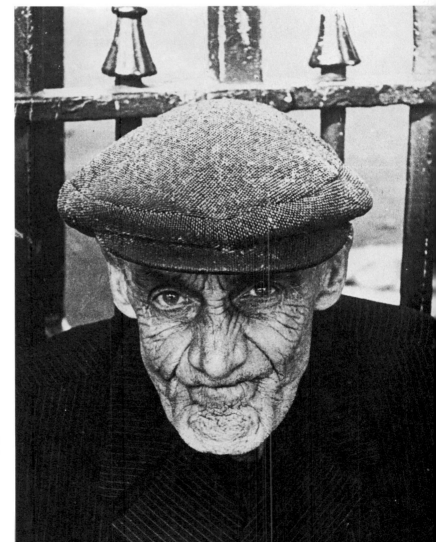

51 An example of the effective use of close-up for photographing people

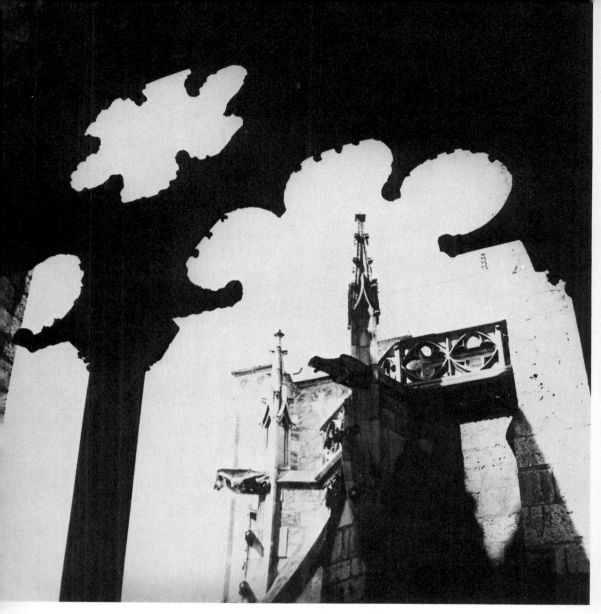

52 The strong black silhouetted shapes in the foreground of this photograph of a French cathedral form an ideal frame for the more distant gargoyles and decoration

Remember that the camera records everything it sees; it is therefore important to cut out irrelevancies and simplify the picture by going in close to the subject. There are, of course, exceptions to this where a tiny figure or group against a wide background can make a very dramatic picture.

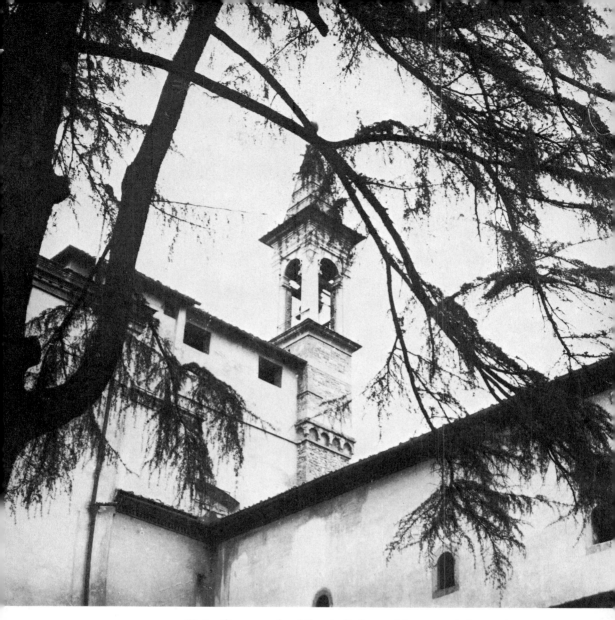

53 Another example of the studied use of foreground: here a tree provides a strong vertical stripe on the left, fanning out into a feathery frame for the tower behind

Depth can sometimes be given to a photograph, particularly a landscape, by including a close-up of some object, perhaps in silhouette, in the foreground, or by photographing the subject through a structure such as an arch or doorway close to the camera (see figs 52 and 53).

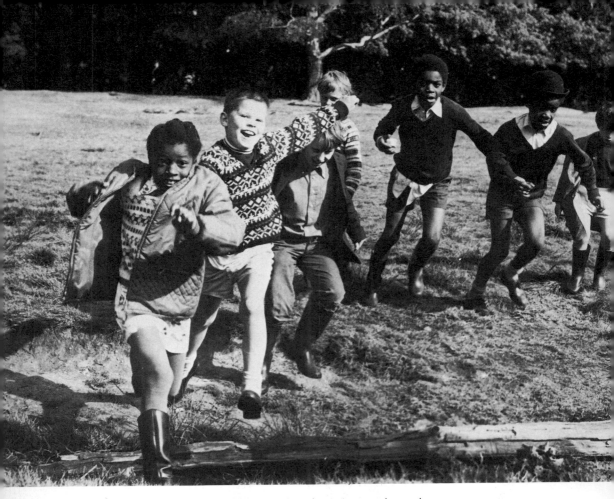

54 In this photograph of children running, the action was frozen by using the fastest shutter speed on the camera, 1/500 second. (Some cameras have a shutter speed of 1/1000 second, so that even faster movement could be recorded)

If your camera has different shutter speed settings you can experiment with taking photographs of things in motion. Many effective results can be obtained and the fact that they are often somewhat unpredictable adds to the interest. A moving object or figure can be 'frozen' by using a fast shutter speed (e.g. 1/500 sec. as in fig. 54), or blurred to give a greater feeling of movement by using a slower speed, as in figs 55 and 56 where speeds of 1/125 sec. and 1/60 sec. were used. When photographing a moving object the camera can be focused on the object itself or on a particular point. If the camera is moved round to follow the object the background will appear blurred.

55 Here the subject has been deliberately blurred to give a feeling of movement, by reducing the shutter speed to 1/125 second

56 When the shutter speed is further reduced to 1/60 second the subject appears still more blurred, creating an even greater feeling of movement

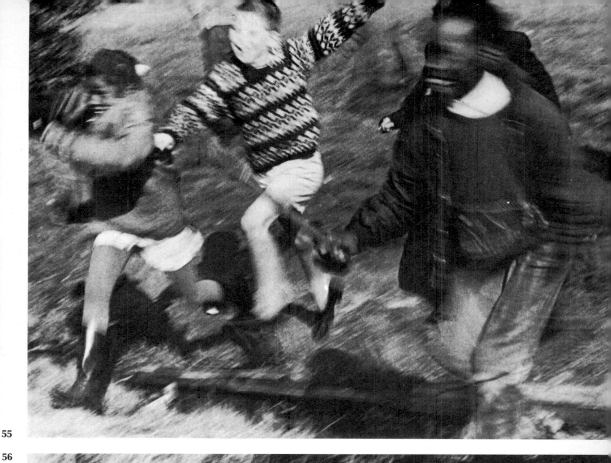

55

56

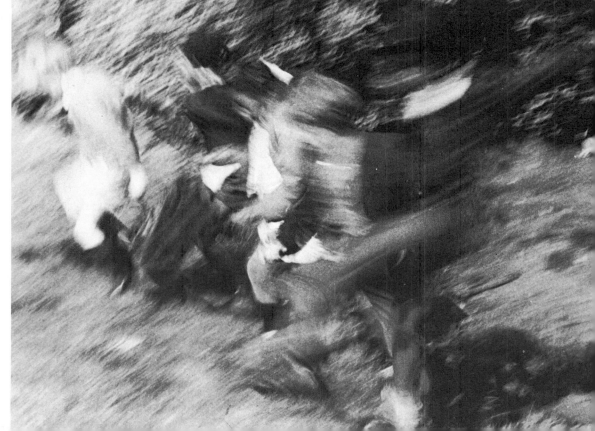

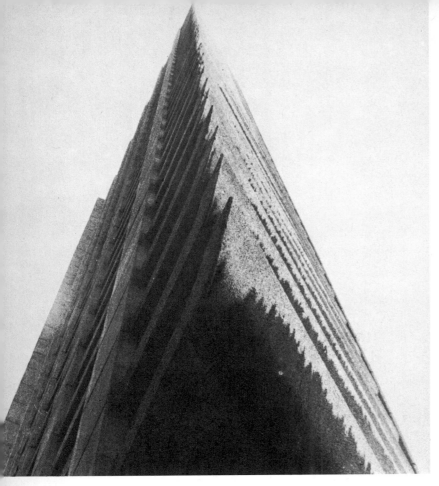

57 In this photograph of a modern tower block, the impression of great height has been exaggerated by leaning back to take the shot from below one corner of the building

Images can be distorted by experimenting with the angle from which you shoot your photograph. Converging vertical lines, which are often considered a great disadvantage particularly when photographing architecture, can be deliberately exaggerated and exploited by leaning back as far as possible to take the photograph. This can be very effective with high buildings (fig. 57).

Wide-angle lenses provide the most extreme distortion of perspective, but the same kind of result can be achieved with any sort of camera if the photo is taken at an extreme angle – for instance, the overworked example of a figure lying down with giant feet towards the camera, or enormous hands holding a glass with a tiny head behind. For this kind of photograph, the camera needs to be focused on a point midway between the nearest and furthest parts of the subject and the lens fully stopped down, to achieve maximum depth of field and sharpness.

Double images and superimposition

When a photograph of an object or a person is taken against a dark background (preferably matt black), the background part of the negative remains in its original state, so that by moving either the camera or the subject another image can be put onto the same negative in the blank space. This can only be done with a camera that does not have an automatic cocking device; many modern cameras will not allow more than one shot to be taken on the same frame as they contain a safety device to prevent this happening accidentally.

Very striking portraits can be made in this way, as shown in fig. 58 where three shots of a girl – one full-face and two profiles – were taken on the same negative.

58 A triple portrait of a girl achieved by taking three shots on one negative. It is important to have a black background for this kind of multiple exposure

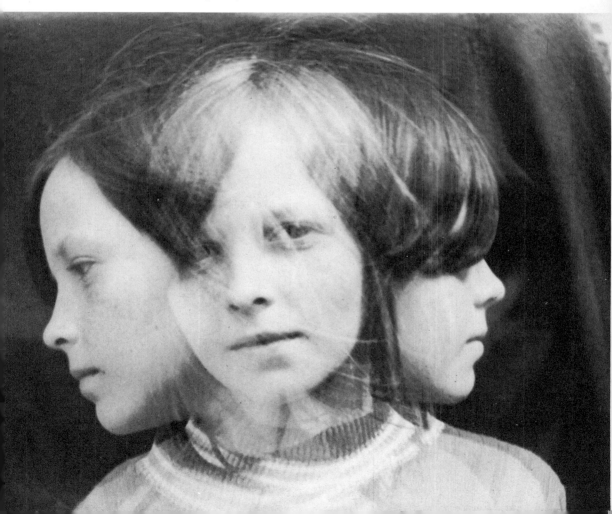

Moving lights

Photographs of moving lights will often yield interesting results; the headlights of many moving cars can be recorded on one negative with a fixed aperture on the camera, or shots can be taken of fireworks by setting the lens with an aperture of about f/4·5 with the shutter left open at Time. Fig. 72 on page 65 shows a swirling pattern made by waving a very bright light about in front of the camera set at Time with the lens wide open.

It should be noted that when using shutter speeds of less than 1/30 sec. the camera must be held absolutely still, either on a rigid tripod or by placing it on a stable surface such as a wall or a

59

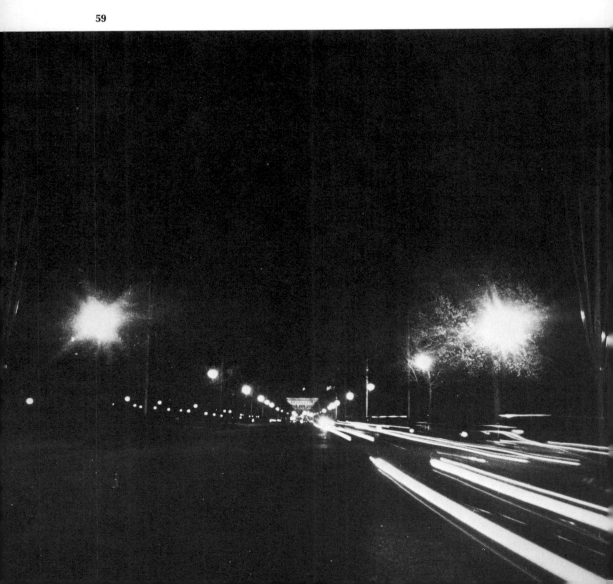

table. In the latter case it can, if necessary, be carefully wedged to the correct angle.

A thematic approach to photography

As I have suggested earlier in this chapter, it is a good idea to have a theme in mind when setting out to take a series of photographs. On pages 41–4 I have shown some examples based on derelict buildings. Reflections provide a theme with numerous possibilities, two of which are shown in

59 and **60** Two photos of streets at night, showing the effect of static and moving lights taken with a fixed aperture; the white lines are car headlights and the blobs are street lights. For this type of photograph make sure the camera is held steady on a tripod or a stable surface

60

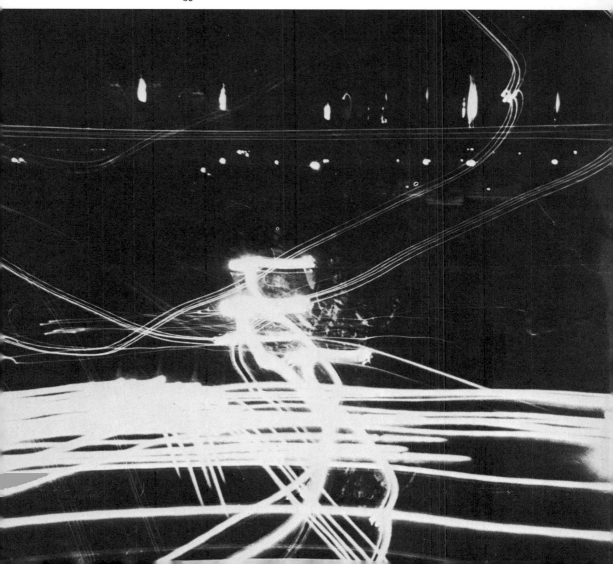

figs 61 and 62. The first shows a tree reflected in a puddle; the slight movement on the surface of the water has broken up the lines of the tree, making it look a little like one of the earlier paintings in the series of tree development by the artist Mondrian. The second is the reflection of a roof and lamp post in a canal, with the swirling grey pattern in the

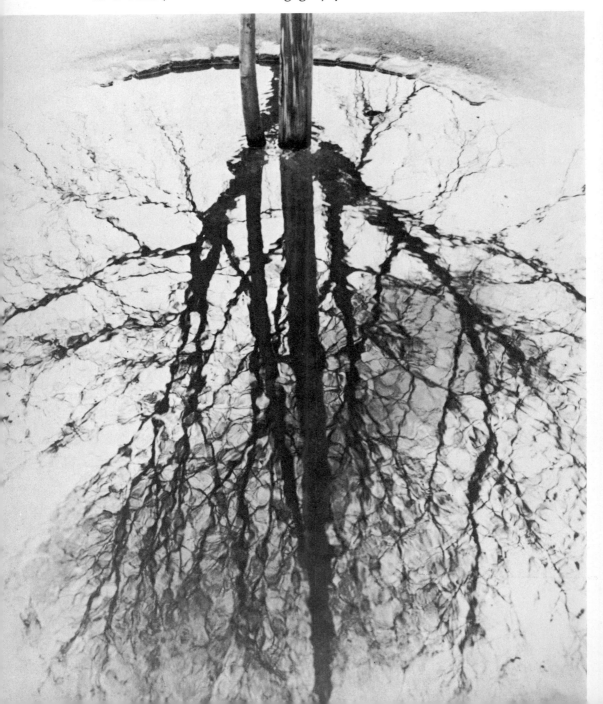

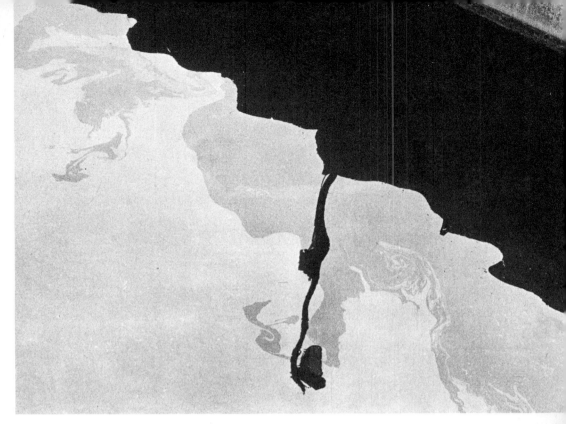

62 Reflections in a canal

middle made by oil on the water. This theme is a natural one for photography and can be exploited in many different ways.

The subject of the theme will vary according to individual choice and the type of location available for taking photographs, but further ideas for themes could include movement, natural forms, structure, surfaces, old people, shadows, etc.

I have suggested a variety of things to look for and remember when you are taking black and white photographs: pattern, vertical and horizontal lines, light and shade, texture, strong foreground images, and getting in close to the subject. The ideas given for a thematic approach to photography could also lead on naturally to an interest in film making. Certainly ideas and vision are vital in the exploration of creative photography and should be developed along with mastery of the techniques; so try to be constantly on the look-out for new and original subjects and ways of photographing them, and do not be afraid to learn by trial and error.

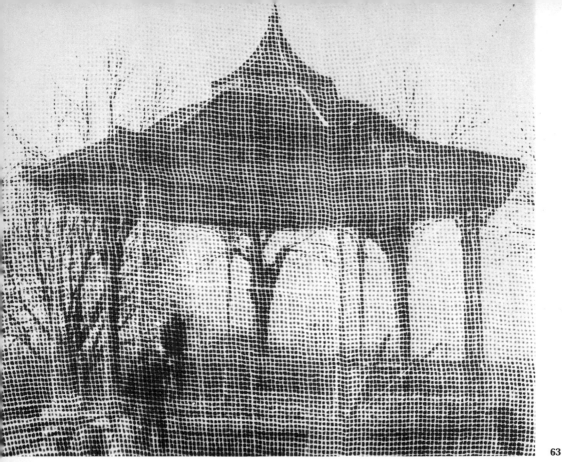

63

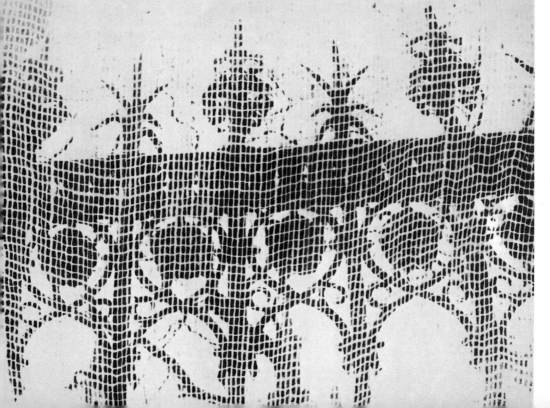

64

3 Experimenting with negatives and printing

Creativity and originality in photography do not only consist of what you choose to photograph. Having taken your photographs, there are a number of ways in which you can experiment when using the negatives to make prints. The equipment and the basic methods and techniques for developing and printing are described in detail in chapter 5. In this section I shall suggest some of the results that can be obtained with them.

Grain
A fast film when considerably enlarged will produce a print with a grainy texture (see figs 44, 51, 57 and 62). This effect can be increased by developing the negative in a universal-type developer instead of a fine-grain one as explained more fully in chapter 5, pages 83 and 84.

Another extraordinary effect can be obtained by developing the negative at a very high temperature – 40–45°C (105–115°F) instead of the standard 18–22°C (65–70°F), which makes the gelatin on the film swell greatly so that wrinkles form on the surface. This is called reticulation and has the effect of covering the surface of the print with irregular dots or patches. It could be disastrous unless specifically required, so it is wise to use a second negative for experimenting (see page 62) rather than the original.

Texture
There are many other ways of altering the texture of a print. Gauze, net or muslin can be put over the negative or the paper during printing; if you are putting it over the paper, the contact should be as close as possible, either under a sheet of glass, or in a printing frame, clipped tightly together between the foam rubber and the glass. Four examples of the kind of effect this can produce are shown in figs 63–66: in the first two, prints of a

63 and 64 Texture added to the print by putting muslin over the negative

65 and 66 Textured prints made by putting vilene (pellon) over the negative

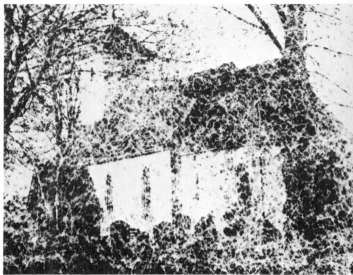

bandstand and a close-up of wrought iron railings, a layer of muslin has been put with the negative in the negative carrier of the enlarger, which gives the impression of seeing the subject through a net-curtained window. In the second pair of prints of a tree and a church, vilene (pellon) lining material has been put with the negative, giving a beautiful ghostly quality to the prints. A variety of experiments with different materials could be done in this way.

Textured or patterned builder's glass can also be put over the photographic paper under the enlarger. A photograph of a tree treated in this way is shown in fig. 67. The addition of the groups of lines all over the print, looking rather like thumb prints, has given it a new dimension and a graphic effect.

67 Another textured effect, produced by placing patterned glass over the paper during printing

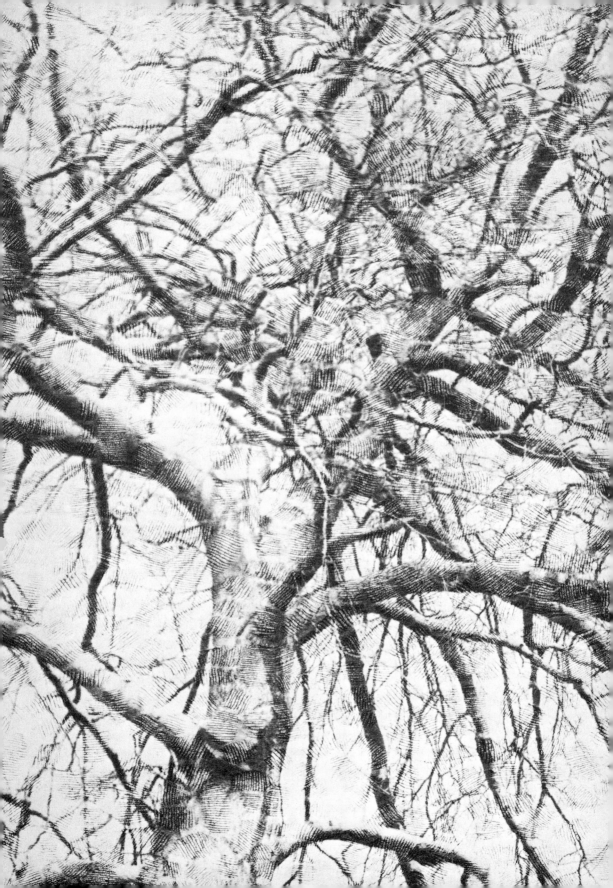

68 A print made from the original negative

Litho or ortho negatives, bas relief
A second negative can be made from the original, thus producing a positive which will make a negative print. This is done on ortho or litho film (sold as sheet film) by contact printing the negative flush with the film in a printing frame under a red light, and then developing the film in a dish as for paper (see page 91). If a third negative is made from the second, we get back to the original negative but with greatly increased contrast; this will make a

69 A reversal print of the photograph in fig. 68, made from a second negative on ortho film

strong black and white print with many of the intermediate grey tones eliminated. Fig. 69 shows a reversal print, made from a second negative on ortho film, of the photograph in fig. 68. It has the eerie quality of a picture taken by bright light in the middle of the night. (The position of the image in these two prints is not identical because there is a slight variation in the area of the negative that has been enlarged in each case.)

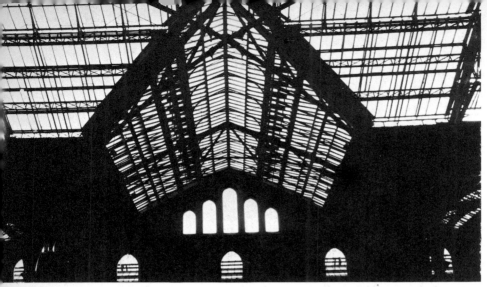

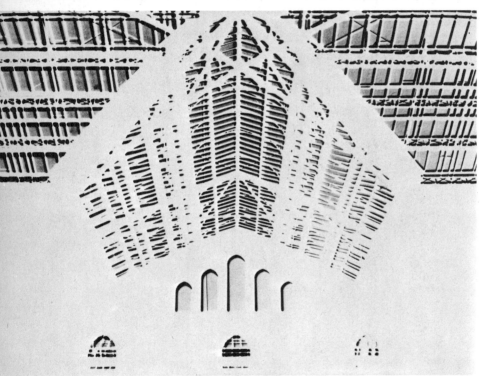

The positive or reversal negative and the ordinary negative can be combined, slightly out of register, to produce a bas relief print, i.e. an image which appears to be slightly three-dimensional. The upper photograph of the roof of a London railway station is a straightforward print, with strong black and white contrast because it was shot against the light. A reversal negative was then

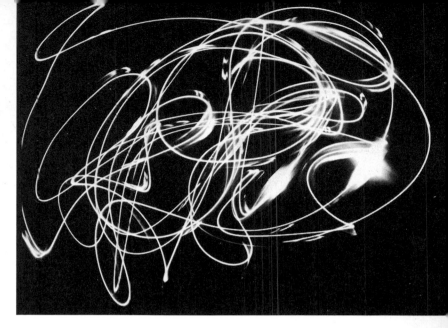

72 Photograph of a bright light waved about in front of the camera with the shutter set at Time and the lens wide open

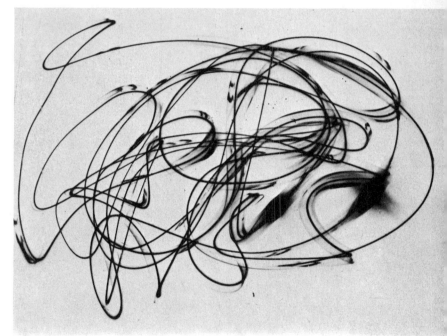

73 A reversal image of fig. 72 made from a second negative on ortho film

made on ortho film and both negatives were put together in the negative carrier of the enlarger, very slightly out of register, to produce the bas relief print in fig. 71.

Fig. 73 is another example of a reversal print.

Photograms can also be made onto ortho film instead of onto paper to produce a negative of the object.

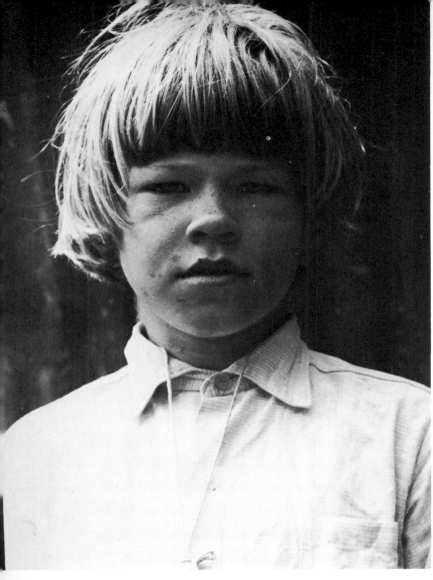

Superimposition and multiple exposure

Superimposition of the subject matter on one
negative when taking the photograph has already
been mentioned (page 53). It is also possible to
superimpose one negative on another when print-
ing, by arranging them in the negative carrier so
that the image on one appears through the white
or transparent spaces on the other. You can judge
the effect by the image thrown onto the base of the
enlarger before the printing paper is put in place.

The position of the negative can be altered
during printing to produce interesting results.
For example, if you have a negative of a full-face
photograph of a person or an animal, you can print

74 and **75** Two prints taken from the same negative of a boy's head. Fig. 74 is a straightforward print, fig. 75 is made with one side of the negative printed twice so that the face becomes perfectly symmetrical

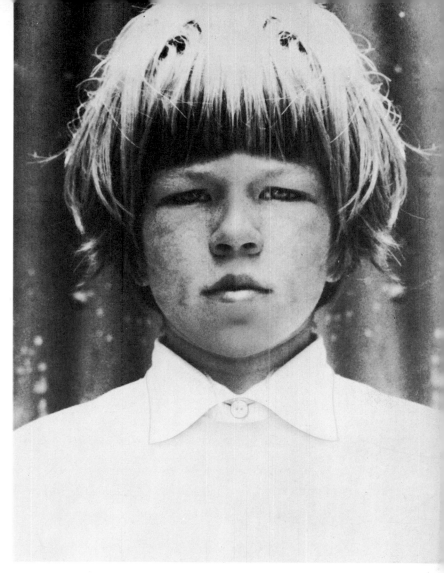

75

one half of it only by putting it into the enlarger with half the image covered by a mask of black paper to block out the light; the negative can then be turned over and the black paper carefully replaced so that the same area of the negative is exposed again, in reverse this time, onto the other half of the printing paper. (To ensure that the masking paper is accurately positioned, mark the edge of the negative with a pencil to show the exact centre of the image.) This will produce a print showing an image of perfect symmetry which can have surrealist qualities, especially with a face that has noticeably irregular features.

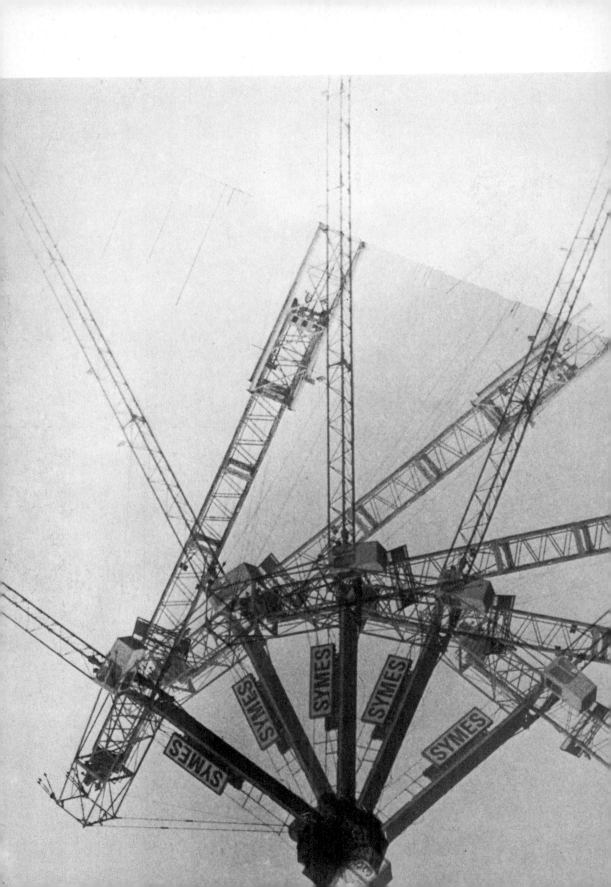

76 Photograph of a crane printed to give a multiple image by rotating the paper four times during exposure

The paper can also be moved during printing to produce double or triple images. This can be done in many different ways. You can simply turn the paper round after the first exposure and then expose it again; or you can move it sideways or on an axis to produce multiple images, as in fig. 76, or an illusion of movement as in fig. 77. The printing light must be switched off while the paper is being moved.

77 A triple print of a boy playing cricket; the paper was moved twice during exposure to create the illusion of movement

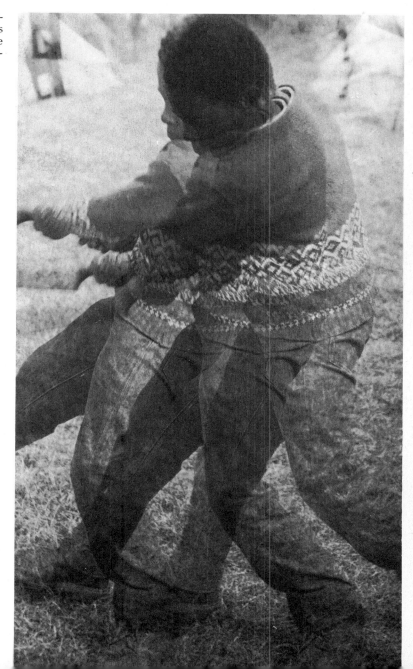

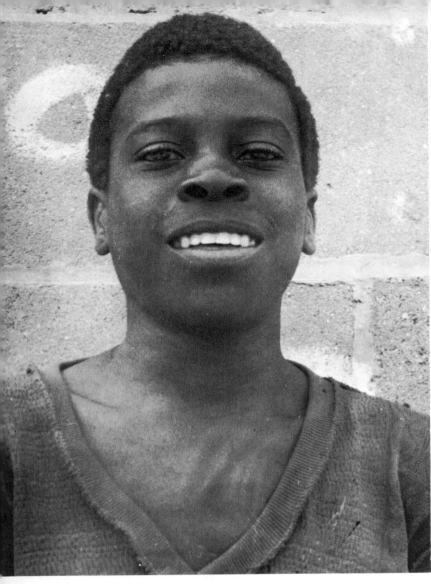

78

Distortion of the image

Images can be distorted when taking a photograph, as described on page 52, either by a wide-angle lens on the camera or by the angle from which the shot is taken; but it is also possible to distort the image on the negative while printing it, by bending the photographic paper so that the image is distorted either vertically or horizontally. If necessary the paper can be held in the desired position by supporting it underneath. It is important to stop the enlarging lens right down – i.e. make the aperture as small as possible – so that as much as possible of the print is in focus. Three examples are shown in figs 79–81.

79–81 Three ways of distorting
the image in fig. 78 by bend-
ing the paper during printing

82 Black Letraset put onto a photogram of feathers to make a poster,
making use of the white area for the lettering

White Letraset applied to a photogram of a thorny twig make a design for a book jacket

4 Other ways of experimenting with creative photography

Graphic design

Lettering can be incorporated into photographs in various ways, for display purposes, posters, etc. Here are a few suggestions:

Black or white instant lettering can be applied to photographs after they have been printed. In figs 82 and 83, two examples are given of Letraset used on photograms for graphic design purposes. In both cases the lettering was added afterwards to the finished print.

A simple negative can be made by applying instant lettering to a sheet of glass or a piece of cellophane which can then be put into the negative carrier in the enlarger together with the negative of the photograph on which the lettering is to appear; in this way a print of any size can be made and the lettering will be enlarged with the print. Alternatively, the cellophane negative of the lettering can be laid over the photographic paper on the base of the enlarger before exposure, so that the lettering will be reproduced the same size while the print is enlarged. In the example shown in fig. 84 the letters and the image combined together make a design which could be used in different sizes on posters, handbills or tickets.

Lettering can also be put onto a photograph using the montage method, either by placing cut-out letters on the printing paper to mask the print during exposure, or by covering the paper with a mask from which the letters have been cut. In the first case the letters will be white against the background of the photograph, and in the second case the photographic image will appear on the letters against a white background (figs 85 and 86). You can design and cut out your own lettering or use large display faces cut from posters, newspapers or magazines.

84 Lettering combined with different sizes of print enlargement

85 Cut-out letters put down on the paper while the print is made will produce solid white lettering over the photographic image

86 When a strip of paper from which letters have been cut out is used in the same way, the photographic image will appear on the letters

85

86

Collage

Fantasy pictures can be created by combining different cut-out images. An arrangement of inconsistent or normally incompatible images or of objects which are deliberately out of scale can often produce unconventional and strangely surrealistic results and incongruous perspectives. There is enormous scope for individual creativity, humour and imagination.

Collage pictures can be made from existing photographs or from magazine illustrations etc. Photographs could be taken specifically with collage in mind, perhaps concentrating on one type of image such as faces, buildings or animals; or photograms could be planned and used together in the same way. A repeating pattern of images can be formed with collage, as in fig. 88. Here four prints were made of the same photograph of a tree,

87 Collage made from a photograph of a village church with prehistoric animals cut out and stuck onto it

76

two of them with the negative turned over in the enlarger to produce an image in reverse; these four prints were then arranged and mounted on one sheet of cardboard to form a repeating pattern. The same sort of effect could be achieved with a wide range of negatives, both of natural objects and man-made structures.

For a better finish and more permanent result the completed collage can then be re-photographed and enlarged to the required size.

5 Equipment and techniques

In the preceding chapters I have suggested a variety of ways in which you can explore the use of photography as a creative medium. In this section I shall give a brief outline of the basic equipment you will need for taking, developing and printing your photographs and of the techniques involved at each stage.

A photograph is a picture recorded by means of the action of light on sensitive film, creating a negative on which the light areas of the subject matter are dark and the dark areas are light. This is reversed when the negative image is projected or laid onto sensitised paper to make a positive print. Both the film and the photographic paper are coated with a light-sensitive emulsion which consists of silver halides suspended in gelatin. They both require processing by the chemical action of (1) developer, which blackens the areas influenced by light, by reducing the silver halides to black metallic silver; and (2) fixative, which removes the unwanted silver halides so that the negative or print will not be further affected by light. Processing is therefore a very essential part of photography, and the way in which it is carried out will affect the quality of the finished print; and even if you are making photograms without a camera or negative, they must be carefully processed to develop and fix the image.

All photographic equipment, both the hardware (camera, enlarger, etc.) and the software (film, chemicals, paper etc.) is expensive, but it is always worth shopping around for possible bargains. In Great Britain, colleges and schools will be able to get percentage reductions through their local authority supplies department. Advertisements in photographic magazines should be carefully compared, as some firms offer tremendous cuts on the recommended retail price for hardware items. It is

also worth considering second-hand items with a reputable guarantee. Film and paper can be obtained at bargain prices too, but check carefully that they are not too old.

Cameras

It is important to use a good quality camera, although some very pleasing results can be obtained from the simplest type of camera, especially in bright, sunny weather conditions.

The simplest camera available is the Instamatic type, which has the same attraction as a casette tape recorder because the film is clipped in as a sealed cartridge and no complicated manual loading is necessary. This type of camera varies from the cheapest, very simple models which work best in bright light conditions to more complex and expensive models which have variations of speed and aperture and can therefore be used in more adverse light conditions and for more sophisticated effects.

It is impossible here to describe every kind of camera, but there are two main types of easily-portable camera for general use. The first is the 35mm camera, which is small and easy to handle. The film is relatively cheap and will take twenty or thirty-six shots. The cheaper models have quite good lenses but only simple viewfinders which have to be held up to the eye. The distance to the subject has either to be measured or guessed at and then set manually on the range scale. The more expensive single-lens reflex 35mm cameras

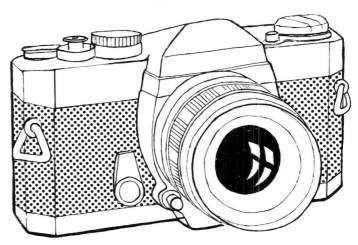

89 Single-lens reflex camera

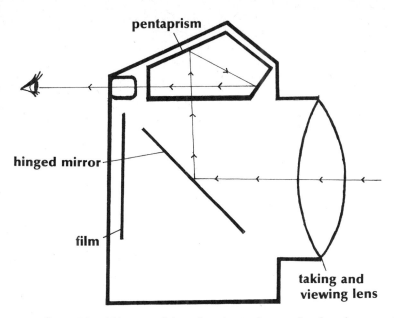

pentaprism

hinged mirror

film

taking and
viewing lens

90 Single-lens reflex camera, showing viewing through lens

(figs 89, 90) provide viewing through the lens, which ensures accurate focusing and positioning of the image in the frame. Another great advantage of this type of camera is the interchangeability of the lenses – standard, wide angle, telephoto and close-up – by special lens or extension rings. The image viewed on the ground glass screen is practically identical to that recorded on the film, so there is no parallax problem (see page 82). Cameras of this type have an automatic device which prevents a second picture being taken before the film has been wound on.

The other type of camera takes a 120 film which provides twelve negatives 6cm × 6cm (2¼ × 2¼in). The twin lens reflex camera (figs 91, 92) is the most general one of this type. It is so called because it has two lenses, one above the other; the bottom lens is the taking lens, and the top one projects the image in reverse onto the ground glass screen of the viewfinder. The large format means that the photographer can compose his picture very accurately. The necessity of looking down onto the ground glass screen and the heavier weight and large size of this kind of camera make it less flexible to use than the 35mm; also the lenses are not so easily interchangeable; but its big advantage is the size of the negative, which is very good for enlargement and experimentation.

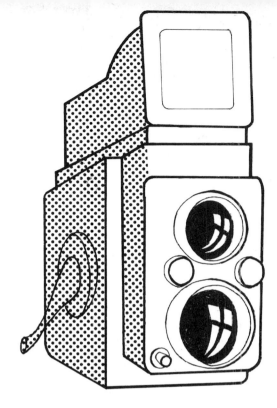

91 Twin-lens reflex camera

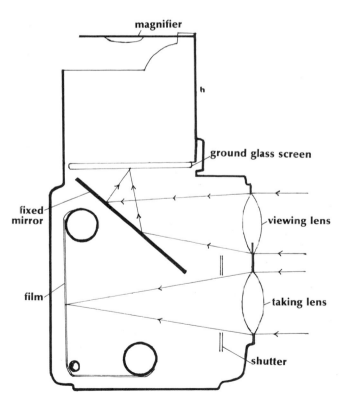

magnifier

h

ground glass screen

fixed
mirror

viewing lens

film

taking lens

shutter

92 Twin-lens reflex camera

The problem of parallax is found both with twin lens reflex and simple viewfinder cameras, but it only becomes significant when the subject is photographed from a distance of less than ten feet. In the twin lens reflex camera the problem is caused by the distance between the taking lens and the viewing lens, so that when taking a close-up the image that will appear on the film will be about two inches below what you see through the viewfinder.

Light meter
If you are using a camera with aperture and lens controls, a light meter (or exposure meter) is necessary to measure the intensity of the light and to calculate the correct exposure time and the size of lens aperture which will give a correctly exposed negative. An under-exposed negative will be pale and without contrast, and an over-exposed negative will be dark and very dense.

Some cameras are fitted with an automatic light meter, but where this is not the case it is vital to have a separate one for accurate work. The film speed or ASA number must first be set on the light meter, and a reading can then be taken by pointing the meter towards the subject. The light scale number which appears in the window is set on the main disc, and you then read off the aperture or f number and the shutter speed and adjust the controls on the camera accordingly.

If your camera has a built-in light meter, you simply set the film speed on the camera dial and then, with the camera pointed at the subject, move the aperture control until the lever in the viewfinder is in the correct position.

Films; different types and their uses
Films have three main characteristics:
1 Speed: that is, the degree of sensitivity to light. Films are graded fast or slow according to their sensitivity and every film is given a rating to indicate its speed, usually in one of two formulae, ASA or DIN. A fast film such a Kodak Tri-X Pan or Ilford

HP4 is given a rating of 400 ASA, is very sensitive to light, and can therefore be used in poor light conditions. Films are rated up to 1000 ASA for indoor work and fast moving subjects. A medium speed film, such as Kodak Verichrome Pan and Ilford FP4, is rated at 125 ASA and this is for general purpose outdoor use. For very bright conditions films are rated as low as 32 ASA.

2 Grain: fast film, in particular, shows a granular quality in enlargement, and the faster (i.e. more sensitive) the film is, the more marked the effect of the grain will be. This is due to the crystals of silver halides in fast film being larger and clustering together. It can be partly compensated for by using fine grain developer (see page 84). Graininess is not necessarily a fault and can often be used effectively (look, for example, at figs 44, 51 and 57).

3 Contrast: this is the degree of difference between the darker and lighter range of tones, i.e. the blackness and whiteness. The slower the film the greater the range of contrast, as a general rule, though the type and tone of development can also contribute.

The choice of film must depend largely on the light conditions available, though it should be remembered that grain and contrast also condition the character of the image produced.

35mm film is mainly supplied in cassette form and provides twenty or thirty-six pictures on a reel. It can be bought in bulk and loaded into cassettes, which will reduce the cost a little. Each negative is 36mm × 24mm and requires great care in handling. Dust on the negative makes pronounced white marks on the print. The print tends to be grainy when enlarged beyond 25cm × 20cm (10 × 8in) unless a fine grain developer is used with a very accurate control of time and temperature.

120 film is a roll film backed with black protective paper, which provides twelve pictures 6cm × 6cm (2¼ × 2¼in). It is suitable for making satisfactory contact prints, if enlargements are not possible. When making enlargements, it is much easier to get good results with this type of film than with 35mm and it is also easier to select part of the negative only for enlargement. The larger negative

also means that a greater degree of magnification is possible before the grain becomes apparent. The only disadvantage is that it is more expensive and therefore more care has to be taken in the shooting of each photograph.

Chemicals

Developer and fixative are the two essential chemical solutions for photographic processing.

As already explained, the reducing agent in the developer reduces the silver salts in the gelatin of the emulsion to black metallic silver. The agent has little effect on the parts of the negative not exposed to light and these silver salts will be washed away in the fix.

There is a wide variety of developers, which can broadly be divided into two categories, normal and fine grain. Their action varies considerably, especially on the tone and grain of the negative, and they can also be used to affect the speed of the film by altering the strength of the dilution and the length of time the film is given to develop.

Generally the fine grain developer is the most suitable for developing films, especially if a fast film has been used, unless you are deliberately aiming for a grainy effect. Normal or universal developers are suitable for developing paper. High contrast developer is available for strong black and white prints.

The fixative solution removes, by chemical process, the part of the emulsion not affected by the light and the developer, thus fixing the negative or print so that it cannot be further affected by light. The main chemical used for fixing is sodium thiosulphate, formerly called sodium hyposulphite (and so 'hypo'), and a weak acid is added to it to stop development and harden the gelatin.

The enlarger

An enlarger is very much like a camera working in reverse: when a photograph is taken, the subject is lit and the film is protected by the camera, whereas when a print is made the enlarger is lit from inside and the paper on which the negative is projected is protected by a red or orange light (see fig. 93).

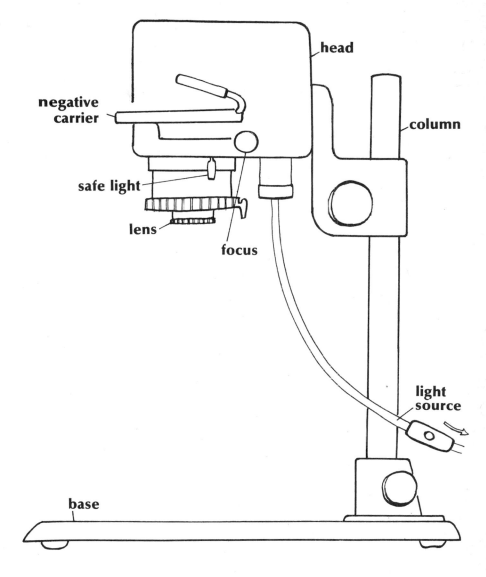

head

negative
carrier

column

safe light

lens

focus

light
source

base

Basically an enlarger is made up of a light source, a pair of condensers to diffuse the light, a carrier in which to put the negative, and a lens attached to a focusing system, with a column which holds everything parallel with the base on which the printing paper is laid. The enlarger head can be moved up and down the column to alter the size of the enlargement, or for very great enlargement the head can be swung round to project the image onto the floor or wall.

Several types of enlarger are available, but two important points to remember are that for best results the enlarger lens should be at least as good as the lens in the camera to do justice to the negatives, and that the focal length of the lens of the enlarger should be right for the size of the negative. A 50mm (2in) focal length lens is suitable for 35mm negatives and a 75mm–80mm (3–3¼in) lens is suitable for 6cm × 6cm (2¼ × 2¼in) negatives. So if one enlarger is to be used for both sizes of negative, a 75mm lens will serve, although the enlarger head will be at the top of the column to produce an enlargement 25cm × 20cm (10 × 8in).

Printing papers

The most generally used printing paper is bromide paper which is insensitive to an orange or red darkroom lamp or safelight.

The surface of the paper can vary from glossy through semi-matt or lustre to matt. For reproduction of the greatest detail glossy paper is ideal, but many people prefer a less shiny surface.

The thickness of the paper can also vary, from very thin through single weight to double weight. Thinner papers are cheaper, but the weight must be chosen to suit the kind of print you require and the purpose for which it will be used.

Printing papers are made in grades numbered 1 to 5 to indicate their relative softness or hardness, so that a suitable paper can be used for each type of negative contrast: softer papers, grades 1 and 2, for over-exposed, dense negatives; normal paper, grade 3, for average negatives; and hard papers, grades 4 or 5, for under-exposed, 'thin' negatives.

For photograms the quality of the paper is less important than for negative printing.

The darkroom

Since unprocessed film and photographic paper must not be exposed to white light except during the making of a print or photogram, developing and printing must be done in a darkroom. The layout of the darkroom is really a matter of common sense. If you do not have a room which can be

kept permanently set up for photographic purposes, a bathroom can quite easily be converted into a darkroom by covering the windows with thick black polythene, black paper or hardboard (masonite). Ideally there should be a supply of running water, though it is possible to manage with containers of water from elsewhere. Electricity for light and for the enlarger, and some sort of working surface such as a table top, are essential, and it is useful to have shelves or cupboards for storing chemicals and paper.

The working surface should be divided so that you have a dry area for papers etc. and the enlarger, and a separate spill-proof surface, which can be easily wiped, for developing, rinsing and fixing.

For most darkroom procedures a red bulb in the main light is adequate, though for better lighting conditions a safelight is useful. Different filters can be put into the safelight: a red filter for ortho films, and an orange one for bromide papers which gives more light to work by. The safelight should be hung to one side of the enlarger, preferably above and next to the developing area.

A developing tank (fig. 94) is needed to develop the film in complete darkness. These can be bought to adjust to different film sizes.

Three dishes are required, two for the chemicals and one for water. They should be enamelled or plastic, at least as large as the biggest paper size you are going to use, and about 2 inches deep.

A thermometer is important for testing the temperature of the chemical solutions, and a measuring jug will be needed for mixing them. A darkroom clock with seconds and minutes marked on it is useful.

A print drier for drying prints after they have been processed is also useful, though this need not be in the darkroom.

If you are working in the bathroom or in any other room not normally used as a darkroom, it is a good idea to put a warning notice on the door while work is in progress to prevent anyone opening it and letting in the light at a critical moment.

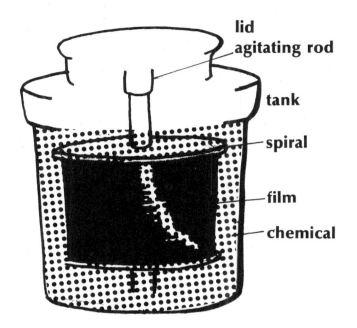

lid

agitating rod

tank

spiral

film

chemical

Using the camera

Loading the film
Having chosen the right type of film to suit the light conditions, you should load it carefully into the camera avoiding strong light. The method varies according to the type of camera, so it is not possible to give exact instructions here.

Taking the photograph
A light reading of the subject should be taken (see page 82) and the aperture (f number) of the lens and the shutter speed set on the camera. The standard speed for a stationary subject is 1/125 sec. or 1/60 sec. The lens aperture will vary according to the lighting, but f/5·6 or f/8 are average apertures. For greater depth of field – i.e. for a longer range of focus – the lens should be stopped down to f/16 or f/22 and a slower speed should be used. Remember that you may need to support the camera on a tripod for speeds slower than 1/30 sec. To 'freeze' fast-moving subjects a fast speed (1/500 sec. or 1/1000 sec.) should be used with a wide open aperture, say f/3·2 or f/2·8.

The subject should be composed in the view-finder and focused carefully. The shutter must then be cocked, if this is not automatic. To take the picture, press the shutter release button firmly but slowly, taking great care not to jog the camera. Then wind on the film ready for the next shot.

Unloading the film

When all the exposures have been taken, the film should be unloaded in subdued light. In the case of the 35mm film, it is rewound into the cassette without opening the camera and the cassette can then be removed from the camera in any light conditions.

Developing the film

Before loading the film into the developing tank, the spiral on the tank must be altered to the correct size for the film. Make sure that you have the film, the spiral, the centre core, the tank and the lid ready and that they are absolutely dry, before switching off the light to load the film in complete darkness. A 120 film must be undone and unrolled from its backing paper before loading onto the spiral. A 35mm can be loaded from the cassette provided that the lead is still sticking out. If it is not, the film must be removed from the cassette by pushing the protruding end of the cassette down onto a hard surface to force off the top.

If any difficulty is found while loading, the film should be put into the tank and the lid replaced before the light is switched on.

Handle the film as little as possible while loading and make sure your fingers are not sticky or damp.

When the film has been loaded into the tank and the lid screwed on firmly, the light can be switched on. Mix up your developer and fixative as instructed on the bottle or packet, making sure the temperature is correct at 18–22°C (65–70°F). Pour the developer into the tank and agitate the tank thoroughly once every minute throughout development. The development time will vary according to the dilution and temperature of the chemical and the speed of the film.

When the development time is up, pour out the developer and rinse out the tank with clean water. Then pour in the fix, agitate well immediately and then again intermittently during the fixing time which will be about ten minutes. Pour out the fix, leave the film on the spiral, and rinse in running water for at least half an hour.

Take the film off the spiral and hang it up to dry in as dust-free a place as possible. There are special heated drying cabinets with racks and clips for drying films, but it is perfectly possible to manage without one of these by hanging the films from a line with a laundry peg; another peg or clip can be put on the end of the film as a weight to prevent it from curling. With a thirty-six exposure 35mm film, it is advisable to cut it in half before drying.

When the film is absolutely dry it should be put into transparent negative envelopes; these can be obtained individually or in file-size sheet form, one page per film, and will protect the negatives from dust and scratches.

Printing the film

With your darkroom set up as described on page 87, you can now print your film.

First mix the developer and fixative solutions, following the instructions on the packet as before.

Some people like to make contact prints of their negatives before enlarging them. To do this, the negative is laid on a piece of photographic paper on the base of the enlarger, under the safelight, with a clean, scratch-free piece of glass over the top, or clipped together with the paper into a contact print frame. The emulsion surface of the negative should be in contact with the paper and the shiny side up towards the light. The negative is then exposed to light from the enlarger; the length of exposure time will depend on the quality of the negative, but to get the best results you could make a test strip as described below. After exposure, the paper must then be processed in the same way as for an enlarged print.

To make an enlargement, choose your negative and polish it with a piece of chamois leather if it is

dirty. Place it in the negative carrier of the enlarger, shiny side upwards. Switch on the enlarger, move the head up the column until the projected image is the size you require for the print, and focus the image by turning the focus knob one way till the image is out of focus and then back the other way to find the exact point of focus in between. Stop the lens of the enlarger down one stop.

Choose the right grade of paper for the type of negative (normal for an average negative, soft for over-exposed, and hard for under-exposed). Then make a test strip by cutting off a strip of the paper, putting it under the image from the enlarger, and covering all but a small part of the image with a thick piece of cardboard. Expose for a few seconds, then move the masking card along a bit and expose again for the same length of time, and so on until the whole strip of paper has been exposed. Develop the strip for two minutes, as described below, rinse and fix, and then look at it in the light and choose the correct exposure time – that which gives the full range of tones from black to white.

The enlarged print can then be made by laying the paper flat on the base of the enlarger, shiny or textured side up, and exposing it for the chosen time. If the paper has a tendency to curl up it can be put in a masking frame or held flat by putting a weight such as a small coin on each corner at the very edge.

If only part of the negative is required on the print, the enlarger head should be moved up until the image appears as large as you want it, and the image focused as before; the printing paper can then be put down on only the part of the image you want to include in the print.

After exposure, put the paper, face downwards, into the tray or dish containing the developer. Agitate the tray well until the liquid has completely covered the paper. Turn the paper over, preferably with tongs (if you use your fingers they must be continuously washed and dried), and continue to agitate until the picture has fully developed. It is important to maintain agitation throughout this stage or the picture will not develop evenly.

Rinse the print in clean water, and then put it into the fix. Agitate well at first, then leave it fixing

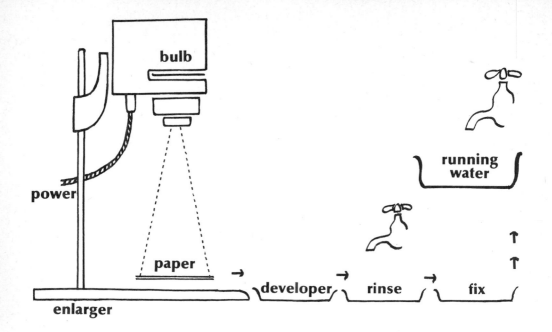

bulb

power

paper

enlarger

running
water

developer → rinse → fix

95 Diagram to show sequence
for making a print

for ten minutes. After fixing, the print should be put to wash in running water for half an hour; if running water is not available the water should be changed at least five times.

The print is then ready to be dried. Put it on a flat surface between two pieces of blotting paper to get rid of excess moisture. It can then be left lying flat to dry in the air, but the edges will curl up and it will have to be placed under a heavy weight when completely dry to flatten it out again. The most effective way of drying is to use a drying machine into which the print is put, face up, on a heated metal bed with a piece of cloth stretched and clipped over it to absorb the moisture. If a glazed surface is required the metal bed is highly polished or a glazing plate is put in.

When the required number of prints have been made, the developer should be thrown away and the fix put into an airtight bottle filled to the top so that no air space is left. If the developer turns dark brown during processing it has worn out and should be thrown away, and a new solution must be prepared.

The negatives should be put back into their protective envelopes until required again, and can be stored in a file so that they are kept flat and dust-free. Prints should also be kept flat, mounted on card, or in a book.

Conclusion

To explore the possibilities of creative photography to the full, it is important to experiment and try out new ideas all the time. While doing this you will probably make many mistakes but these need not always be disastrous, they can often lead to unexpected and interesting results.

Keep your eyes open for exciting photographs, ideas and techniques in books and magazines. If you have a museum within reach that has any examples of early photographs or photograms, go and look at them. Watch out for specialist exhibitions; sometimes photography is included in the exhibitions put on by the big art galleries, and you may be able to find a photographic gallery which specialises in showing the work of contemporary photographers.

Suggestions for further reading about technical information and ideas are included in the booklist on page 96.

Photographic images, particularly those which are very black and white, are suitable for silk screen printing, so that many of the ideas described in this book could be used as designs for silk screen to be printed on paper or on fabrics. The image has to be transferred to a light-sensitive screen by direct contact with a full-size negative or transparent print. In a similar way photographic images can be printed on many different surfaces such as ceramics and canvas if these are first given a light-sensitive coating. The techniques of silk screen and photography for ceramics etc. are outside the scope of this book, but if you are interested in exploring this field details can be found in other books, and it is worth investigating the photographic section of your local bookshop or library.

Glossary

Aperture The size of the lens opening in camera or enlarger, normally controlled by an iris diaphragm, which determines the amount of light passing through; indicated by the 'f' number – the lowest number indicates the widest aperture.

Bromide paper Photographic printing paper coated with an emulsion containing silver bromide; insensitive to red or orange light.

Clearing (the film) The length of time it takes for the milky look of the unexposed silver halides to disappear, which indicates about half way through the fixing stage.

Condensers A pair of large lenses in an enlarger which together diffuse the light from the enlarger bulb so that it covers the negative evenly.

Contact print A print made on paper (or film) by perfect contact between the emulsion of the negative and that of the paper (or film).

Depth of field The length of distance which is registered in focus on the negative. The range can be increased by stopping down the lens of the camera – e.g. by setting the aperture to f/22; conversely, a wide aperture will yield a limited depth of field.

Emulsion The light-sensitive coating, of silver halides suspended in gelatin, on film or paper.

Film speed Indicates the sensitivity of the film to light.

Focal length The distance between the lens and the point where the image is formed on the film when the lens is focused on infinity (∞).

Grade of paper Ranges from 0 (very soft) to 5 (ultra hard) – see page 86. A contrasty negative suits a soft paper, while a 'thin' or underexposed negative is better printed on a hard paper.

Grain The clumping of grains of silver halides on a negative which gives a textured effect to the print. It is more apparent on a fast film.

Light meter (Exposure meter)	A light-sensitive cell connected to a meter scale which shows the amount of light reflected from the subject; used to calculate the right exposure time and lens aperture to produce a correctly exposed negative.
Litho emulsion	A very high contrast emulsion.
Masking frame	An adjustable frame for keeping the paper flat on the base of the enlarger.
Negative	An image on film (or sometimes on paper) with the light values of the subject reversed.
Negative carrier	A metal or glass holder in the enlarger designed to keep the negative flat during exposure.
Ortho film	Film with an emulsion which is sensitive to all colours but red.
Panchromatic film	Film which is sensitive to all colours.
Parallax	Occurs when the viewing screen on the camera does not share the lens which takes the picture. In twin lens reflex cameras the distance of approximately two inches between viewing and taking lenses could become a problem when taking subjects in close up.
Safelight	Used in the darkroom to protect light-sensitive film and paper; has a red or orange filter.
Shutter speed	The length of time the film is exposed to light through the shutter when taking a photograph. For correct exposure, the speed is calculated by use of a light meter and must relate to the aperture (as a general rule, the wider the aperture the shorter will be the exposure time required).
Silver halides	Light-sensitive salts (usually silver bromide and silver iodide) used to make up emulsion.
Stopping down	Reducing the amount of light passing through the lens by narrowing the diameter of the aperture.
Telephoto lens	A lens with greater focal length, e.g. 90mm in a 35mm camera.
Wide angle lens	A lens of short focal length and therefore lower magnification than normal which covers a wide field of vision (60° or more).
Zoom lens	A lens of variable focal length which can change the angle of view from a wide angle to telephoto, or the other way round, while keeping the same focal point.

Further reading

Design by Photography by O. R. Croy; Focal Press, London and Amphoto, New York

Croy's Creative Photography by O. R. Croy; Focal Press, London and Amphoto, New York

Creative Photomicography by O. R. Croy; Focal Press, London and Amphoto, New York

Making Photograms by Virna Haffer; Focal Press, London and Hastings House, New York

Photography for Designers by Julian Sheppard; Focal Press, London and Hastings House, New York

Photography in Art Teaching by Alan Kay; Batsford, London

Creative Photography by Aaron Scharf; Studio Vista, London and Van Nostrand Reinhold, New York

Practical Screen Printing by Stephen Russ; Studio Vista, London and Watson-Guptill, New York

Silk Screen by Michael Casa; Van Nostrand Reinhold, New York